new
from *old*

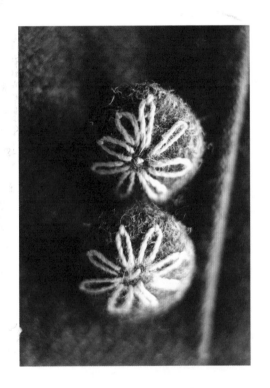

new *from old*

How to
transform
and customize
your clothes

JAYNE EMERSON

MITCHELL BEAZLEY

First published in Great Britain in 2006 by Mitchell Beazley,
an imprint of Octopus Publishing Group Ltd,
2-4 Heron Quays, London E14 4JP

The author has asserted her moral rights

ISBN 1-845-33177-X
ISBN 978-1-845-33177-X

A CIP record of this book is available from the British Library

Set in TheSans and TheMix
Colour reproduction by Chroma Graphics Pte Ltd, Singapore
Printed and bound in China by Toppan Printing Company
Limited

Senior Executive Editor Anna Sanderson
Project editor Susan Berry
Designer Anne Wilson
Editor Sally Harding
Photography John Heseltine
Stylist Susan Berry
Illustrations Janet Haigh
Production Seyhan Esen and Faizah Malik

CONTENTS

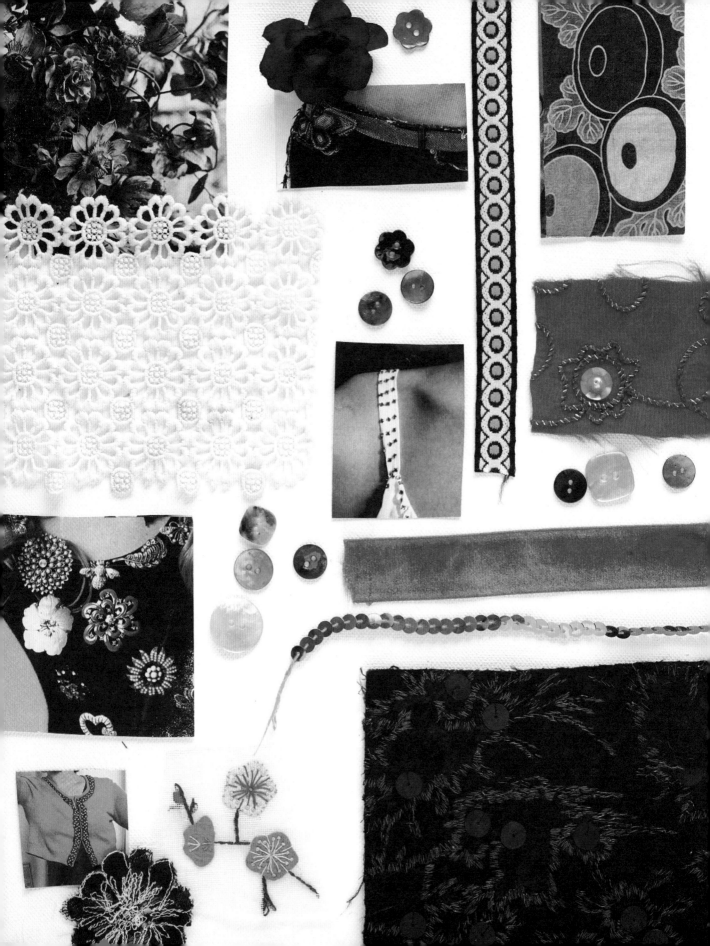

Introduction

● ●

Fashion is constantly changing, and keeping up with the latest trends can be difficult, especially if they don't always suit you! Finding your own style is key when arranging your wardrobe, and well-fitting clothes in colours and styles that suit you are always going to look good. This book is not a project book, although instructions are given at the back for the more complex but still easy projects. It is a sourcebook to whet your appetites, inspire you, and get the creative juices flowing. In these days when fashion has become such a throwaway commodity, it is important to get some individuality back into your wardrobe.

You might be able to go into the high street and get fantastically embellished clothes, but they will not be one-offs unless you pay a fortune for them. Also, you are unlikely to find the perfect garment in the right colour, fabric, and length, and with exactly the right amount of decoration. The joy of creating your own clothes and accessories is that you can tailor them to what you want and what suits you.

This book also helps you widen your search when shopping, and gives you ideas for what to do with things you were going to throw away. You might have, or find, a skirt in the fabric you love but not the shape. You might have a silk blouse that is the wrong colour or a jumper that is just plain boring. This book can give you inspiration to rescue the good qualities in an item and make something wonderful from it that is entirely yours.

I always gain a real sense of pride and satisfaction from completing a new piece of clothing, and when done properly, it looks like a designer one-off! The secret when customizing your clothes is not to overdo it – a few well-placed stitches or a dip in the right colour can be all it takes to breathe new life into the fabric. Of course, there is always scope to go mad and do something eccentric. Just go with what suits you and your personality. If you keep one eye on the trends in the glossy magazines you will never be short of ideas.

SIMPLE CUSTOMIZING

I am hooked on shopping in charity shops, and I love looking at old home sewing books from the 50s. Having said that, I am not someone who likes to spend hours stitching, but I do like the idea of being able to personalize my wardrobe so that my things look just a bit different. If I do buy something in a chain store, I am more than likely to jazz it up in some way.

Ever since I can remember, I have been playing with textiles, and I am aware that some of the simplest ideas are also the most effective. There isn't room in this book to cover all the ideas I have, but I hope I manage to inspire you to have a go at customizing and creating your own designs. The greatest joy of finding and revamping charity-shop finds is that even if you make a horrible mistake, you haven't really wasted any money and, in any event, the charity has already benefited!

The ideas in this book are not difficult (I wouldn't do them if they were), and there is a section at the back of the book that gives you some basic information. I am assuming, though, that if you have a

Finding bargains

Charity shops are great places to find inexpensive clothes to remodel (below). Secondhand accessories or inexpensive new ones are also good candidates for customizing (right).

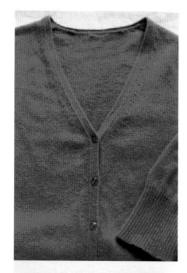

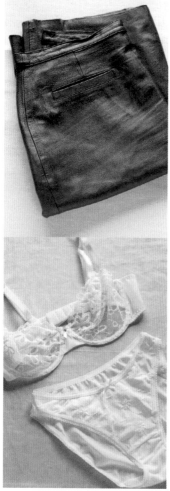

sewing machine, you know how to work it. Of course, you may get hooked on the whole idea of revamping your wardrobe, and take it much further than I have. I've included various ways of making new garments from old in this book – dyeing, embroidering, adding beads, sequins, and buttons, cutting items up to make completely new ones, and doing minor alterations. I haven't included professional alterations, because you need to be an expert to do this well, and it's no fun wearing something that looks badly finished.

CHOOSING ITEMS TO REVAMP

When looking around in charity shops, you will gradually develop an eye for what to pick out. The key is to check the quality of the fabric. Most garments have a fibre-content label, and natural fabrics are the ones to choose almost all the time. Cotton, linen, silk, and pure wool are great. They wear well, wash well, and keep their appeal even when old. They also take dye well, and are nice to stitch. Manmade fibres tend to look good when new, but have a horrible tendency to go limp and dull after being cleaned a few times.

A hideously shaped charity-shop dress in a beautiful print might be just the thing to make into a scarf; an old-fashioned leather skirt can be turned into a chic handbag. A plain jumper or blouse can be given a great new look by decorating it with beads or braid. A boring beige linen skirt could take on a whole new existence dyed burnt orange, and bordered with another fabric.

Another place to look is in cheap chain stores. For the outlay of a few pounds, you can acquire some good basic plain cotton T-shirts or simple cotton skirts and trousers that can then be transformed into something much more individual and special.

When picking out items of clothing, you will no doubt have a fairly clear idea of what suits you. If you know that high necks are not your thing, and you see just the right T-shirt with the wrong neckline, then it can be transformed into a much more suitable one very easily. Equally, a skirt that is too short can have a border added.

Simple transformations

Choose plain items to personalize (left). You can add appliqué to a cardigan, make a leather skirt into a bag, and renew plain lingerie with dye (right).

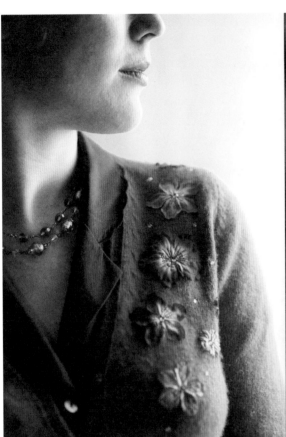

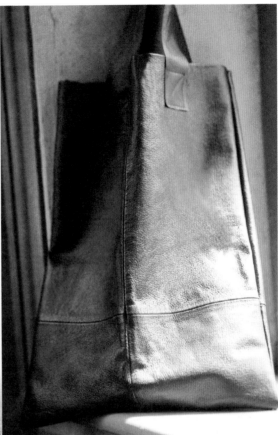

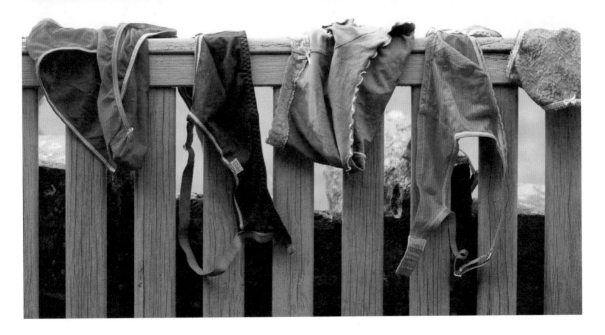

Collection of ideas
Collect fabric, photos, accessories, beads, threads, or anything else that catches your eye (right). These are all going to help you develop your own ideas and sense of style. Pin things from your collection to a noticeboard to inspire you, and it will keep you on the lookout for more ways to transform and customize your clothes.

Be careful, though, of picking items that are not really in your power to adapt, such as trousers or tailored skirts. But you can fairly easily make a simple dress or blouse a bit more fitted using tucks.

You are not limited to garments, either. Shoes, bags, scarves, and necklaces can all be recycled to advantage, with a bit of ingenuity. Find a good pair of shoes in boring beige and dye them, customize bags with a bit of stitching, put new buckles on old belts, make belts out of silk scarves, and restring old beads for new necklaces.

CHOOSING COLOURS

Colour is a really personal thing, so it is hard to offer advice on what to opt for or, indeed. what might or might not suit your skin colouring. But as you will see looking through this book, I have a particular colour story that I like, which is not a colour palette as such. I pick colours in the mid-tone range that go well together because they have the same level of colour saturation (the colour density). To understand what is meant by tone, as opposed to pure colour, look at a page with a bright multicoloured images and squint your eyes. You will start to see dark and light, as opposed to colour. Tone is exactly that. The degree of darkness or lightness of a colour (in other words how much, if any, black is in its make-up).

Choosing colours with a similar tonal value is the key to clever colour coordinating. It has two great benefits: it never looks overly planned, and it gives you the chance to be more creative and make things look more interesting. Once you opt for this mid-tone colour story, putting colours together becomes much easier, and you can mix all sorts of colours that your mother would have told you firmly not to do, like greens and blues, or purples and oranges.

KEEPING A STORYBOARD

I always think it is worth having a noticeboard for pinning up great ideas, colours, anything that inspires. It is your personal statement about what you like and dislike, and keeping it in a prominent place somewhere will help you edit your own choices into a cohesive look that gives you your individual style. That is not to say it won't change from year to year, but it will help guide you in your shopping forays, and, with luck, prevent you from buying just about anything and everything you see! Good hunting!

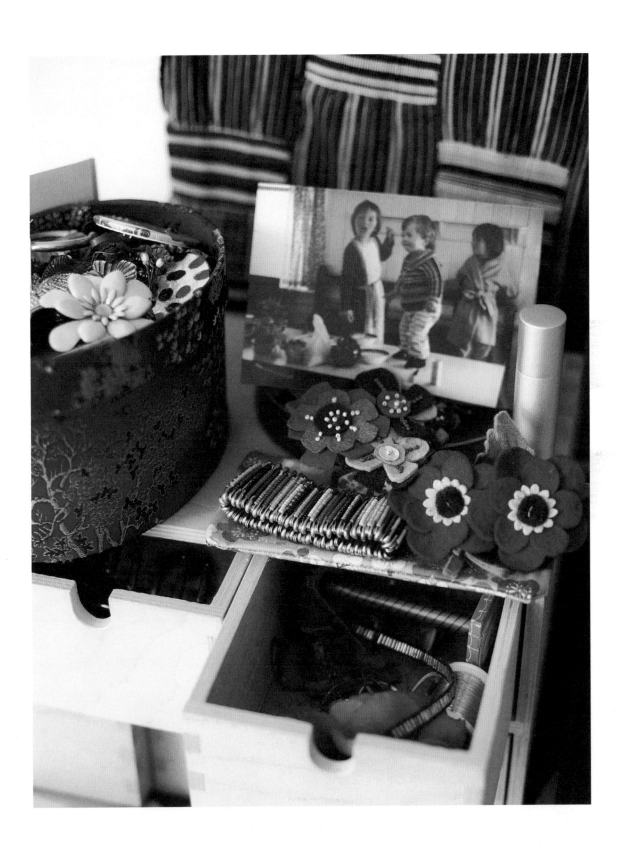

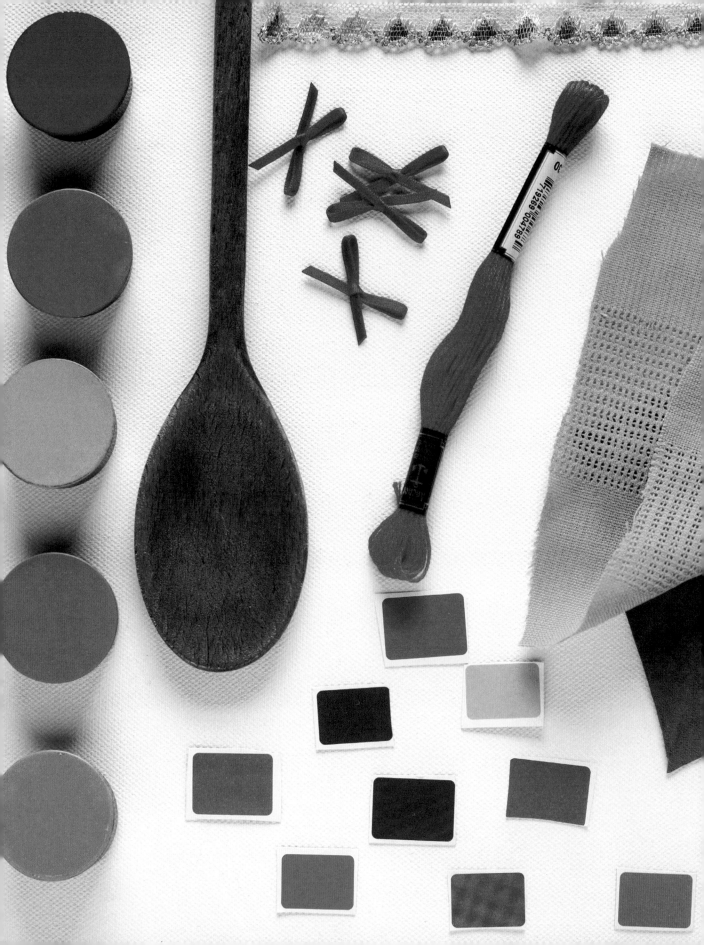

Before you start

• •

Colour is a very personal thing, so it is very difficult to suggest to anyone what range of colours to opt for. However, it is absolutely true to say that colours date fast, and this season's hot colour will be next year's stale news. So, if you have some nice clothes (or find old ones in charity shops) but the colour is not right, then dyeing them makes good sense.

You do need to be careful, however, as although there are very easy home dyes that you can use and a range of dyeing methods for different fabrics, you need to know what to use when. The easiest method of all is to use a machine-wash dye. For this method, you simply follow the dye manufacturer's instructions. Make sure you read the instructions carefully; they outline the amount of dyestuff to use for a particular weight of fabric in order to achieve the full strength of the dye. Too much fabric, and the dye shade will simply be weaker.

Dye colours and strengths

Not all fabrics take dye in the same way, and so, for example, if the piece you intend to dye is made of pure cotton but is topstitched with synthetic thread, the stitching is likely to dye to a lighter colour if it takes the dye at all. If you want to change a dark-coloured garment to a lighter shade, you will need to strip the original colour using a purpose-made dye remover to create a blank canvas to dye.

I have dyed a whole range of items in this chapter, and there are many, many more I could have dyed (and probably will!). I hope the examples encourage you to have a go, particularly at some of the more esoteric forms, such as over-dyeing or tie-dyeing. The latter is a major craft in Japan. Japanese designers produce some truly wonderful tie-dyeing effects, particularly with indigo dye, which is singularly beautiful – as the strength of the indigo dye bath weakens the colours become even more stunning.

• • • • • • • • • • • • • •

Funky thermal vests

Three versions of the vest (above) were all dyed in the washing machine with different shades of a standard hot-water dye. As you can see, the lace at the neck was more resistant to the dye and, in the case of the brown vest, turned a scintillating orange (opposite). With the other two vests, dyed red and olive green, the lace turned pink and lime green respectively (right). (See instructions on pages 126-127.)

REINVESTED

One of my first dyeing experiments was with a thermal vest I bought in a chain store, but that only came in black or white. I had made a pair of cotton pyjama trousers out of a spots print (see pages 96-97) and wanted a comfortable camisole top to wear with them in bed.

The result was quite unexpected. I dyed this mixed-fibre (polyester/viscose) thermal vest in dark brown dye in the washing machine. I hadn't much liked the lace at the neckline and planned to change it, but lo and behold, when I dyed the vest, the lace turned a scintillating orange, ending up looking like something out of a posh mail-order catalogue, to my delight. I added the orange buttons, to make it look less like a happy accident.

I then had a go at a couple more vests for my friends, dyeing one olive green and the other rose red. In both cases, the lace around the neck dyed to a much lighter shade than the body, but not quite as unexpectedly as the orange with the brown.

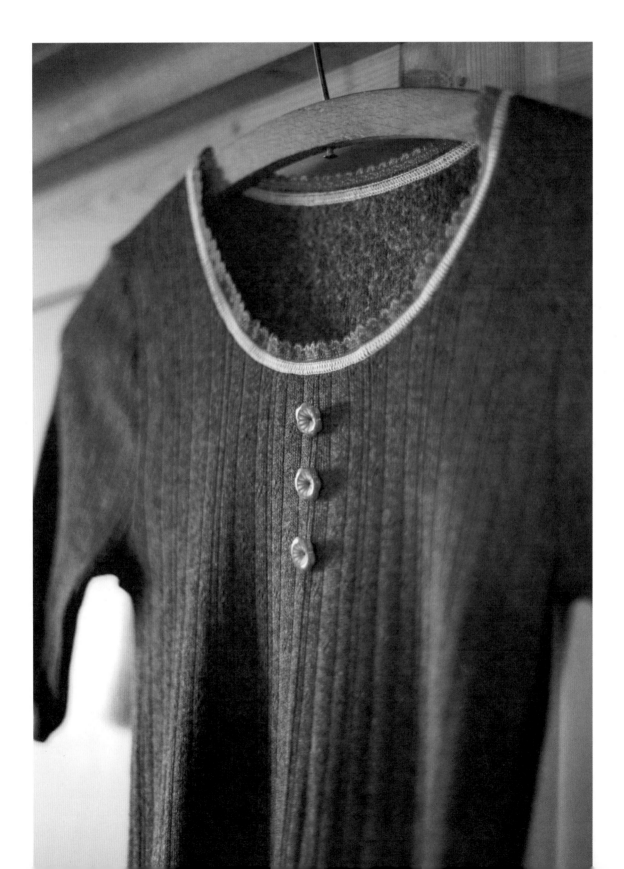

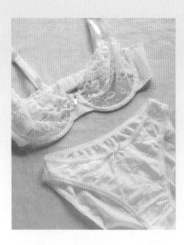

TRANSFORMING LINGERIE

Encouraged by my success with the thermal vest, I decided to put some new life into my old and rather unappealing white (or not so white) lingerie. This was one of my most satisfying dyeing attempts, I think, and I ended up dyeing not only mine but my mum's underwear, too. She now sports some pretty funky colours under her rather more sober shirts and skirts!

I made a big collection of all my old underwear, yellowing bras, and dingy vests and pants, some cotton, some polyester, and some with mixed polyester/cotton trims (well, let's face it, we all have them). I bought three separate dye pots. I thought I would experiment with some quite strong colours – jeans blue, shocking pink, and bright orange. To my delight, the different bras, pants, and

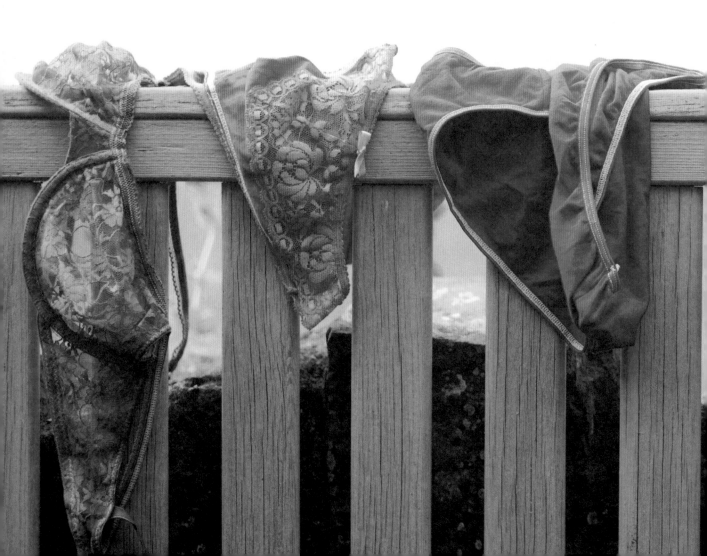

vests all took the dye really well, coming up in some good, strong colours. I didn't feel the need to mix any colours for these, because I wanted a much brighter range than for my other clothes, which is precisely what I got.

So, for the price of a couple of pots of dye, I gave my underwear a whole new lease of life. What is more, contrary to my expectations, you can wash dyed garments the second time without them running. (Just in case, you should still put coloureds in the wash only with other coloureds, not with whites.)

Flushed with success from my underwear transformation, I started to look around for other undergarments to dye. Next in the dye bath was an old white broderie anglaise petticoat that had been in the bottom of my drawer for years. I was reluctant to throw it

Bold and brilliant underwear
If you are bored with your old white underwear, give it a facelift by dyeing it in different colours (below). Be warned, though, that different fabrics will not come out precisely the same colour, so if you want close colour matching, dye a shop-bought set, made from the same textile (opposite).

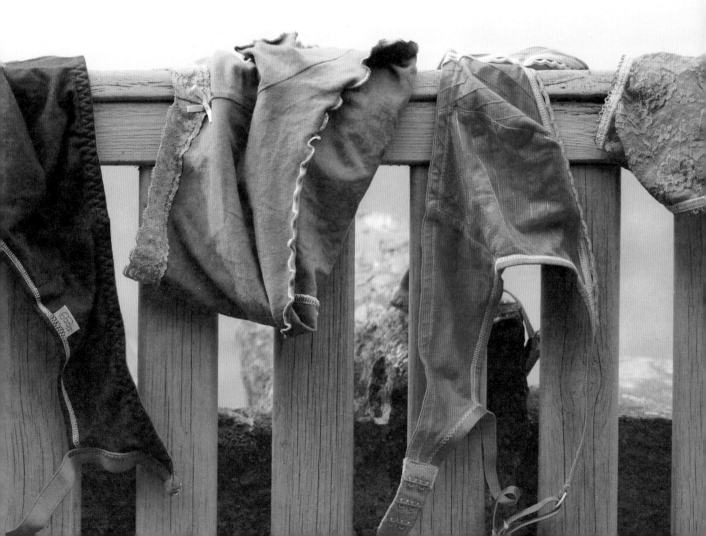

away because I liked the lace, but couldn't really think what to do with it, or what to wear it with. I dyed it bright orange because I liked the colour I got from the vest, which was synthetic. This time around I was dyeing cotton, and it took the dye brilliantly in one easy machine-dye process. Just remember to run a hot cycle on the machine after dyeing anything in it, to get rid of any residues so that your next wash cycle isn't spoiled.

I guess I could wear the transformed petticoat on its own, but it makes a pretty cool underskirt for a brown linen skirt I have, particularly when worn with the edge just peeking out below the hemline. Even if you decide to wear a dyed petticoat so that it doesn't show below the skirt hem, it's great to be able to see a flash of a contrasting colour when you move, without actually flaunting it. I have a really great designer-label skirt in very sober grey flannel, which sports an acid green silk lining that you only catch a glimpse of when I am sitting down, so I suppose that is what gave me the idea.

In passing, I want to sing the praises of broderie anglaise. It has appealed to me ever since I saw an old film with Brigitte Bardot (who sported a grey denim bathing costume with a broderie anglaise trim at the neckline). One of the best things about this particular lace type is, firstly, the fact that it is cotton (so much nicer to wear next to your skin) and, secondly, you can do interesting things with all the little cut holes – threading ribbon through them for one.

For a complete revamp of lace, take a look at the skirt made out of a round tablecloth on page 93, which was a common or garden cream one until I dyed it brilliant scarlet, and made a flamenco-style dance skirt out of it.

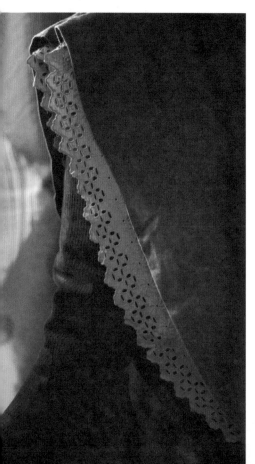

Coloured lace trim

If you don't have a handy antique petticoat, like the one here that I dyed bright orange (top left and right), you can buy a length of broderie anglaise. Dye it in a hand-dye bath as for the trims on page 26, and attach inside the bottom of your skirt (left). You could even add two in contrasting colours: a bright turquoise would look nifty with this colour combination.

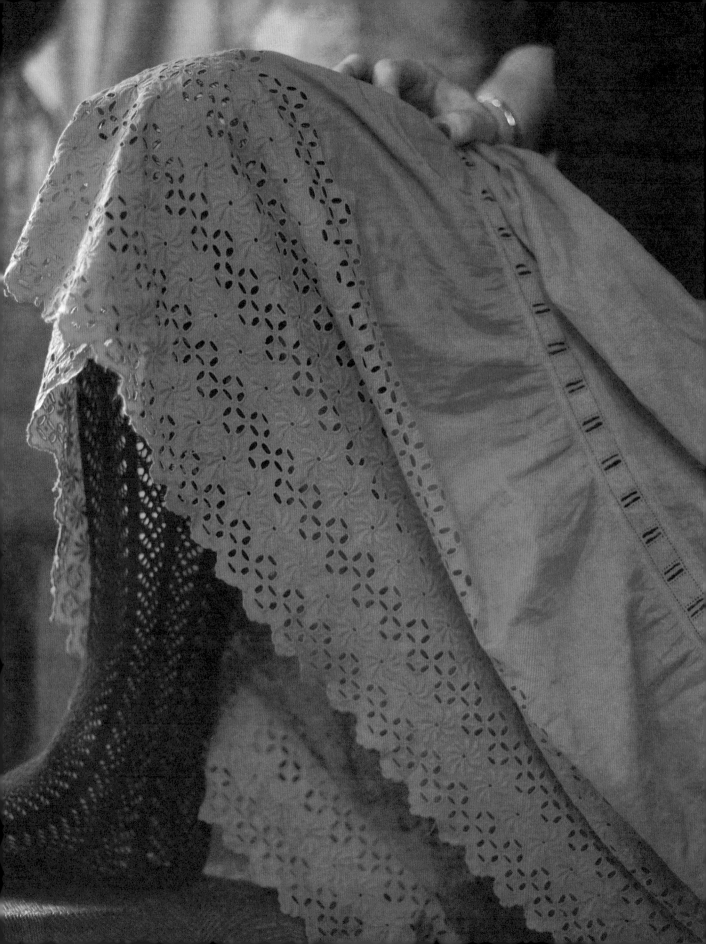

• • • • • • • • • • • • • •

Spot on

This blouse was a pretty shape
and I liked the collar (above).
Unfortunately, the colour was
insipid and didn't go with any of
my other clothes, so I dyed it blue
with great results (opposite). You
can create some interesting
colours by over-dyeing. These are
classic combinations (below).

OVER-DYEING

Once you have become reasonably proficient at dyeing, you can
start to be more adventurous and actually change existing colours.
But first you need to understand how colours will change
when over-dyed.

If your garment is already coloured, then the dye colour will
create a new shade, but not necessarily the shade on the dye packet.
The effect is similar to painting, because the new dye colour will
simply combine with the existing colour to create a combination of
the two. Put a yellow skirt, for instance, in a blue dye bath and it will
turn green. Put a blue skirt in a red dye bath and it will turn mauve.
You can get precise information on the results from the dye
manufacturers, but you are inevitably going to have to experiment.
Make sure the item being dyed is not precious, in case the new
colourway disappoints you. However, you often get some wonderful
happy accidents, and if you were going to throw the garment away
(or you bought it for a song in a charity shop), it's great fun to see
what happens. If you don't like the result, take it back to the charity
shop, or dye it black, which covers most colours perfectly well.

As always, beware of topstitching, as this might not take the dye
to the same depth of colour as the main garment. You can
sometimes use this to great effect to make an interesting feature of
the stitching – particularly if you bear this in mind when choosing
your new dye colour.

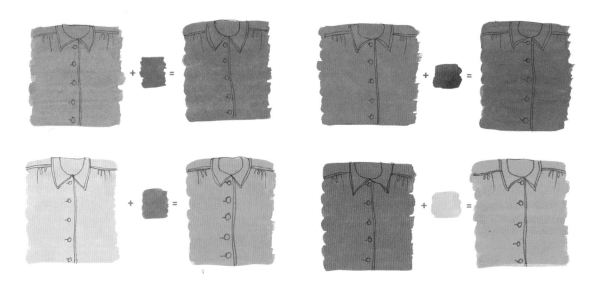

DYEING TRIMMINGS AND ACCESSORIES

If you don't fancy taking the risk of dyeing an entire garment, you can always add some trimmings to jazz up a boring skirt or blouse. It is often hard to find the colours of trimming you want, so why not simply dye the trimmings in a hand-dye bath (see page 28) to the required colour? You can use the trimmings to add borders or edgings to trousers or skirts for example. See the cropped trousers on pages 86-87 for ideas for how to do this. Remember that if the trimmings you use are already coloured, the resulting dyed colour will be an amalgam of the original colour and the dye colour (see page 24).

If you like, put other small items in with the trimmings and dye them at the same time. I put in a plain white cotton pair of gloves, and trimmed the cuffs with one of the braids, as I wanted them for a wedding outfit.

Dyed lacy braids
The selection of fine lacy braids in white, off-white, and pastels (above) was quickly hand-dyed in mauve dye to produce quite a subtle colour change (below).

Dyed and trimmed gloves
The trimming was then added to a pair of white gloves, dyed in the same dye bath (opposite). Just the thing for a smart wedding .

Dyeing other items
Although buttons can be dyed, too, you need a special process dye (which is stronger than fabric dye).

I dyed some pearl buttons every time I had a different dye bath on the go, and then added mixed coloured buttons to a plain blouse. The left-over coloured buttons will find a home on future projects.

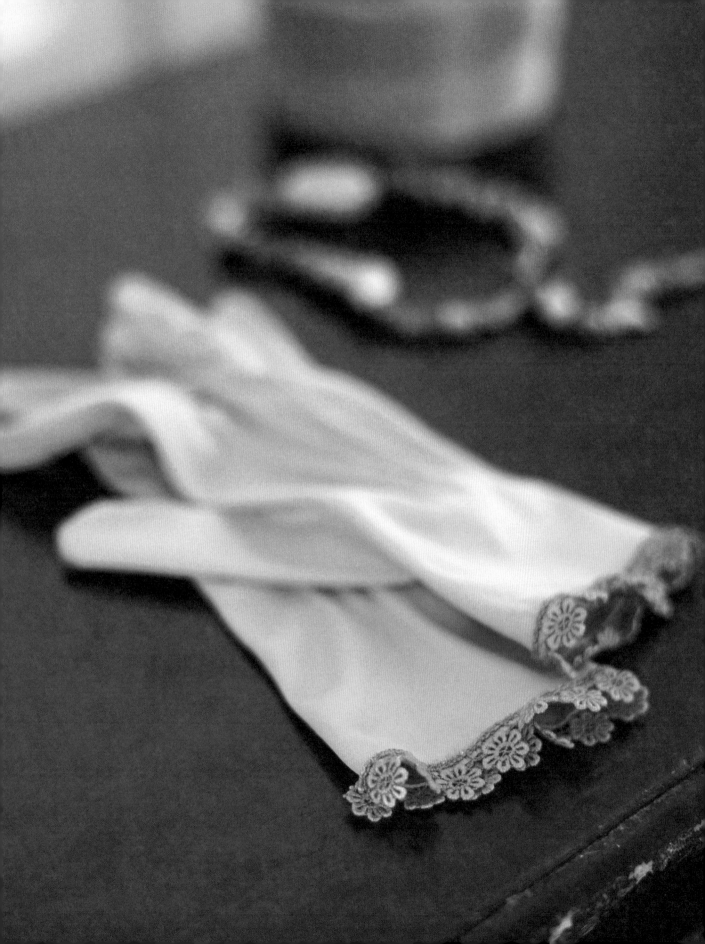

Hand-dyeing

Hand-dyeing is great for lightweight or small items, such as trims or braids. You can even dye buttons (see page 26). Hand-dyeing is also ideal if you have to dye something to an exact shade (for example, matching a trim to a top) because you can take the fabric out of the dye bath at any time.

To hand-dye, dampen the trims, put them into the prepared dye bath (see page 126), and stir for as long as instructed. You will see the

fabric begin to take up the dye and change colour. Take the trims out of the dye bath at intervals to test the colour strength.

When the desired shade is reached, rinse the trims under the tap. Then lay them on an old folded sheet and iron dry. If the colour is still too pale, dunk the trims back in the dye bath for longer. If they go too dark, add a bit of bleach to the dye bath.

For further information on dyeing, see the instructions on pages 126-127.

DIP-DYEING

Dip-dyeing is just another hand-dyeing technique. It gives great results because it creates subtly graded shading, from deep to pale. I have used it on various things, but think it works best on skirts, nighties, dressing gowns, and scarves. As with all forms of dyeing, you need to make sure the item you are dyeing is not topstitched, as the stitching thread might not dye to the same colour as the fabric. Beaded fabrics, however, will usually dip-dye beautifully.

You achieve dip-dye effects by leaving the end of the fabric with the deepest colour in the dye bath the longest and the lightest part of the fabric in the dye bath for the shortest period of time.

Dip-dyeing a scarf

If you are dip-dyeing a scarf and want both ends the same colour, dip the whole of the scarf into the dye bath, then gradually pull it out of the dye bath from its centre, making sure the ends stay in the longest. With nightdresses and skirts, you only need to hold the top part of the item, and then gradually pull the garment out of the dye bath, so that the hem remains in the dye the longest and turns the deepest colour.

Gradations of colour
Dip-dyeing produces a wonderfully subtle effect. It works particularly well on long items, such as a scarf (above), nightdress (below), or skirt, with the deepest colour at the hem. The beaded scarf was dip-dyed in shades of apple green (opposite). (See instructions on page 100.)

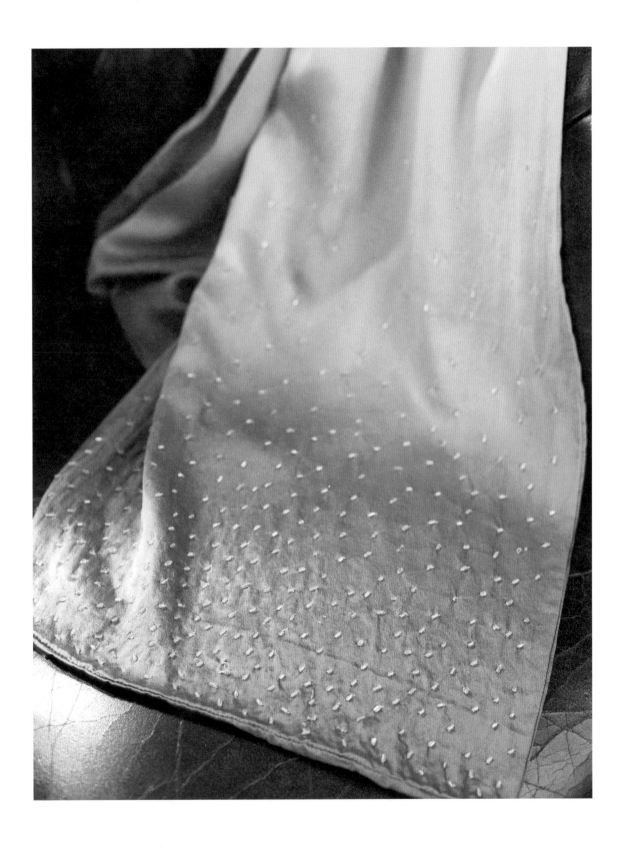

TIE-DYEING

Tie-dyeing is an art that has been practised in Asia and Africa for centuries, often in conjunction with indigo dyeing, to create wonderfully intricate white patterns on deep blue fabric. In its simplest version, as shown here, it is ideal for adding a bit of decorative detail to a plain garment.

I had a very plain white skirt that I became bored with, in part because it was also a rather ordinary shape. To make it into something more appealing, I decided to dye it with a denim blue dye and to create a tie-dyed border above the hem. This technique consists of simply tying the fabric with string before dipping it in the dye bath in the usual way. The string prevents the area of the fabric under from taking the dye.

Adding more decoration

You can make more elaborate decorations by tying the fabric in several places, by dyeing it in progressively deeper colours, or by dyeing it twice, to achieve different colours. I also tie-dyed a vest in denim blue, but this time tied the straps in three places to create three distinct lines of resist patterning on the shoulder area.

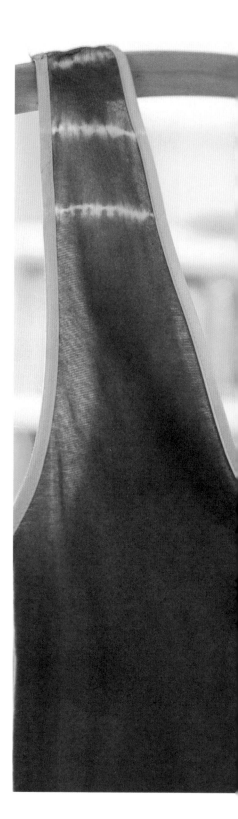

Bored with plain white?
A plain white skirt that has lost its freshness, like this one (left), can be transformed into something quite different with denim dye (far right). Just tie the skirt above the hem with string before dyeing it to create a white border. A white vest takes the same treatment well (right).
(See instructions on page 101.)

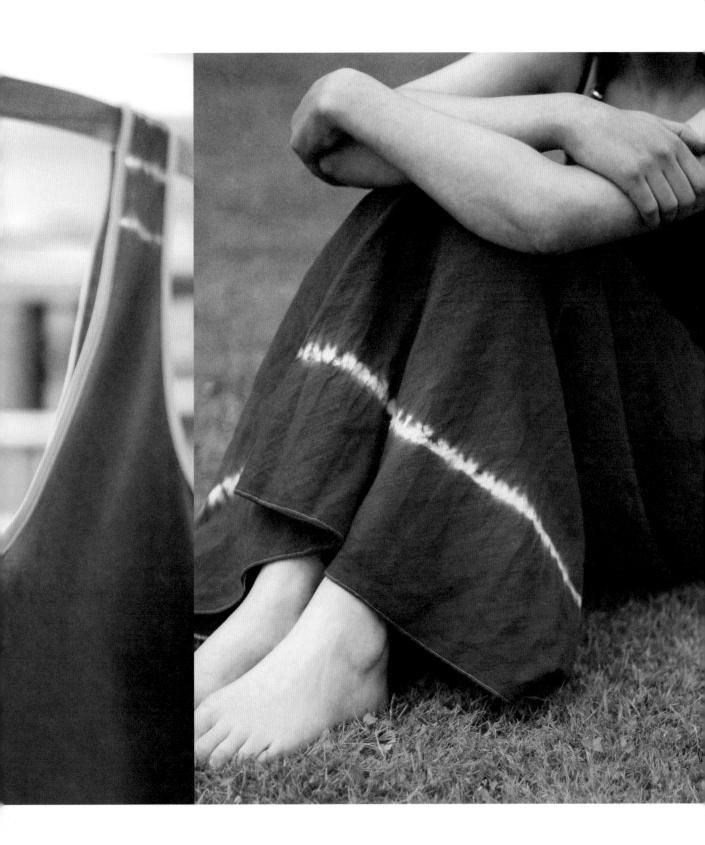

TRANSFORMING SHOES

If you are like me, you hoard shoes, even those you no longer wear. You probably don't wear them because they don't go with anything any more. Still, for the small outlay of the price of a bottle of shoe dye, you can transform these unworn shoes into the perfect accessory for a night out, a wedding, or a party.

When dyeing shoes, you need to follow the dye manufacturer's instructions carefully, in particular making sure that there is no polish left on the shoes. Remove all traces with white spirit. If you

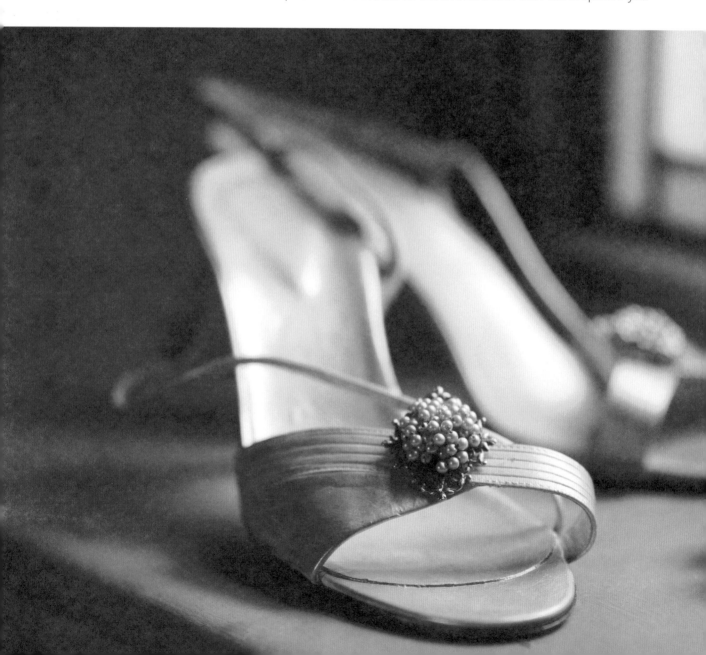

fail to do this, the dye will not take and will start to peel off. When dyeing sandals, where the inner sole is often visible, you need to take particular care not to splash dye on the inner soles, so cover the edges with masking tape. If you wish, dye the toe area of the sandal, too.

If simple dyeing sounds a bit tame, be more adventurous and create a pattern on a pair of plain sandals or shoes, using a stencil. The same stencil can then be used for a similar design in fabric paint on the hem of a skirt or fabric bag.

Stencilled spots

Take the whole shoe-dyeing concept a bit further by adding decoration using a stencil (below). This works well on a pair of simple sandals with a plain vamp. (See instructions on page 102.)

Party time

Do you have a pair of shoes that you like but they no longer go with anything (right)? Dye them a different colour, clip a pair of earrings onto the vamp, and bingo, a completely new pair of shoes for the price of a bottle of instant shoe dye and a couple of earrings (left). Great for weddings or last minute invites!

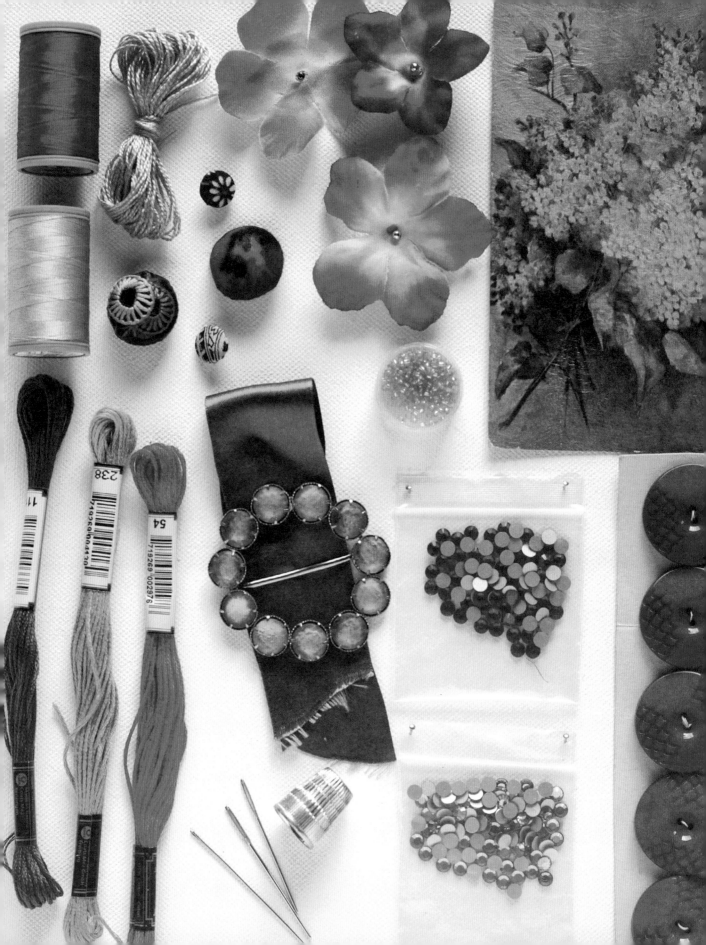

Before you start

You can stylishly customize all kinds of garments, as well as bags and shoes, by adding a few trims or some interesting stitching. The old adage that you can't make a silk purse out of a sow's ear is true, but you can certainly make it look much more attractive! That said, the first thing to ensure is that the items you want to decorate are made from good-quality fabric, and that the overall garment is well-designed and well-constructed.

I love playing around with decorative ideas, whether adding interesting braids, changing the buttons, adding a bit of sparkle in the form of beads or sequins, or doing some simple hand or machine embroidery. Hand-embroidered garments always look great and are currently very fashionable. However, less is more when it comes to decoration, so pick ideas that are quite minimal but eye-catching: a few hand stitches on the lapels of a jacket or an appliqué flower on a knitted jumper. This will look sophisticated and less home-made than if you piled on the stitching!

You don't have to be an expert seamstress or embroiderer to achieve great-looking results, but you do need to position the decoration in the right place, and make sure the proportions are right for the garment. I have included some basic information on stitching in the section at the end of the book, and it will probably pay to look through this before you begin.

In this chapter, I have included a wide range of ideas, but there are hundreds more that I could have added! I hope those included here whet your appetite and get your creative juices flowing.

It helps if you have a good collection of trims, buttons, and beads at your disposal. If you discard clothes, make sure you keep any old buttons; they may well be just what you need to jazz up a boring jacket or skirt.

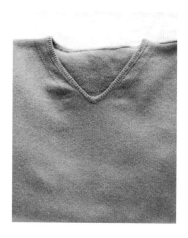

RIBBONS AND BRAIDS

There is no better way to give a plain garment a lift than to add a bit of decoration to it. There are some wonderful ribbons and buttons around these days, as a visit to a speciality ribbon store or a button counter will quickly reveal. If you don't find the colour you want, you can always dye your own (see pages 28-29). To jazz up a plain woollen jumper or V-neck top for a special occasion or for partywear, why not stitch a length of silk or Petersham ribbon around the neck of a plain sweater? On a kimono dressing gown, use a contrasting cotton ribbon as a tie belt – a plain ribbon on a striped or check fabric, or vice versa.

Fine ribbon goes well on cotton tops, and more elaborate silk or velvet ribbons and bows on heavy silk evening blouses or dresses. Wide ribbons look best in soft, flowing fabrics, such as velveteens or satins. You could also use them as ties to fasten a plain jacket.

Transforming a jumper
If you have a plain V- or round-neck sweater (above) that needs a new look, stitch a length of satin ribbon around the neck and tie it in a bow. If the ribbon is not bias cut, pleat it to fit it around the curves (opposite) and secure the pleats with small backstitches or machine stitching. (See instructions on page 106.)

Petersham ribbon
Following the same theme, you could stitch a contrasting Petersham ribbon to a V-neck sweater and tie the ends in a bow (right). As it is slightly stretchy, Petersham ribbon will adjust to the neck shape without pleating.

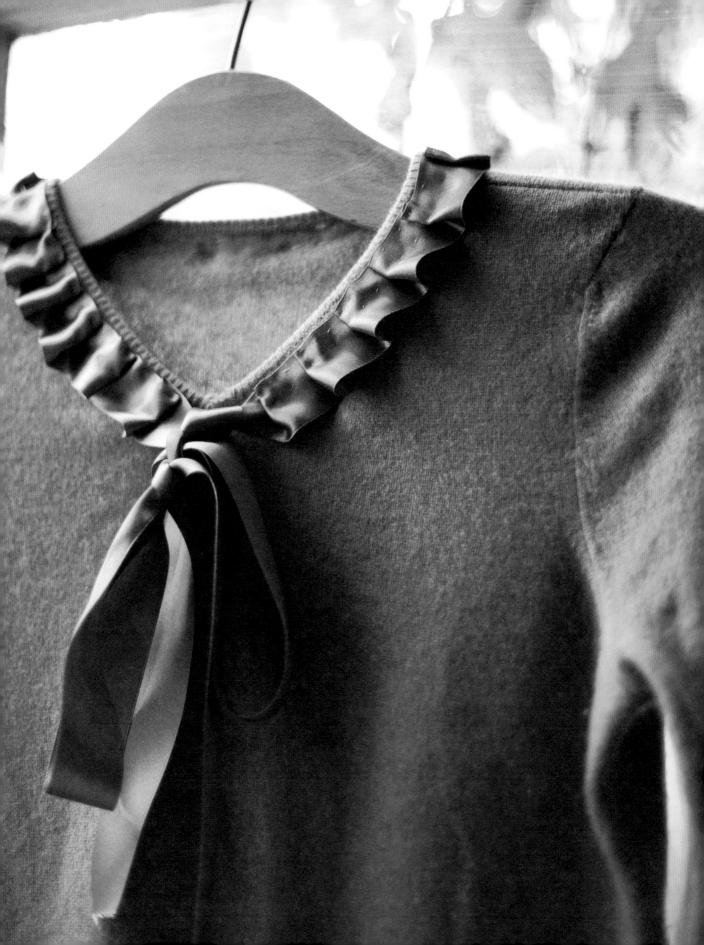

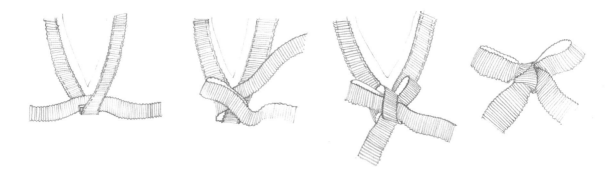

Tying a bow

When adding a ribbon around a neckline (as on the previous page), it helps if you can tie a neat bow. Here is how to do it!

To glamorize a chain-store cardigan or jumper, look at high-end fashion design for the tricks of the trade. For example, add a contrasting ribbon to a cardigan button band, then sew on matching expensive luxury buttons to give it a touch of class; or, for a particularly nice touch, trim the edge of a cardigan with a pretty floral ribbon.

If you don't want to add ready-made braid, why not create your own braid using the sewing machine? The camisole here has been given a new look with a machine-embroidered edging that looks great. It is actually surprisingly easy to stitch. All you need is a basic sewing machine and some water-soluble vanishing fabric. The benefit of this kind of edging is that it effectively prevents raw edges from fraying. So if you cut a neckline to a new shape (see pages 90-91), this is a decorative and quick way to seal the edges.

Fancy edging

This little top originally had a round neck (right). I cut it into a V-shape, then machine embroidered the neck edge over water-soluble vanishing fabric. The result is an attractively lacy border that would be just as effective along the edges of a bolero (left) made like the one on pages 68-69. (See instructions on page 107.)

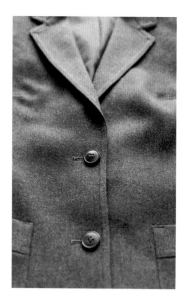

EMBROIDERING A JACKET

All of us have at least one plain jacket in our wardrobe that lingers unworn because it isn't very exciting. Don't let it go to waste because it can be transformed with some very simple decorative additions. One of the neatest tricks is to emphasize the outlines of the lapels, yoke, or pockets with hand stitching in a contrasting thread. If you are not an expert embroiderer, it is best to limit yourself to easy-to-work stitches, such as long and short stitches or French knots. You can achieve great results with hand stitching and little professional skill (see pages 137–139).

I also often simply change the buttons on a jacket, adding either antique ones or ones I've made myself. Nowadays you can buy button-making kits, for covering buttons quickly and easily with fabric. If you wish, embroider the fabric first for a touch of elegance (see pages 48-49).

Decorative detail
You don't always need to make great changes to improve the appearance of your clothes. Even quite subtle decoration can be used to great effect. A plain jacket (above) was given extra interest with simple stitches on the lapels and yoke (far right).

French knots
A similar effect can be created with the jacket using little French knots rather than long and short stitches (right). Pick a good contrasting colour to make the greatest impact.

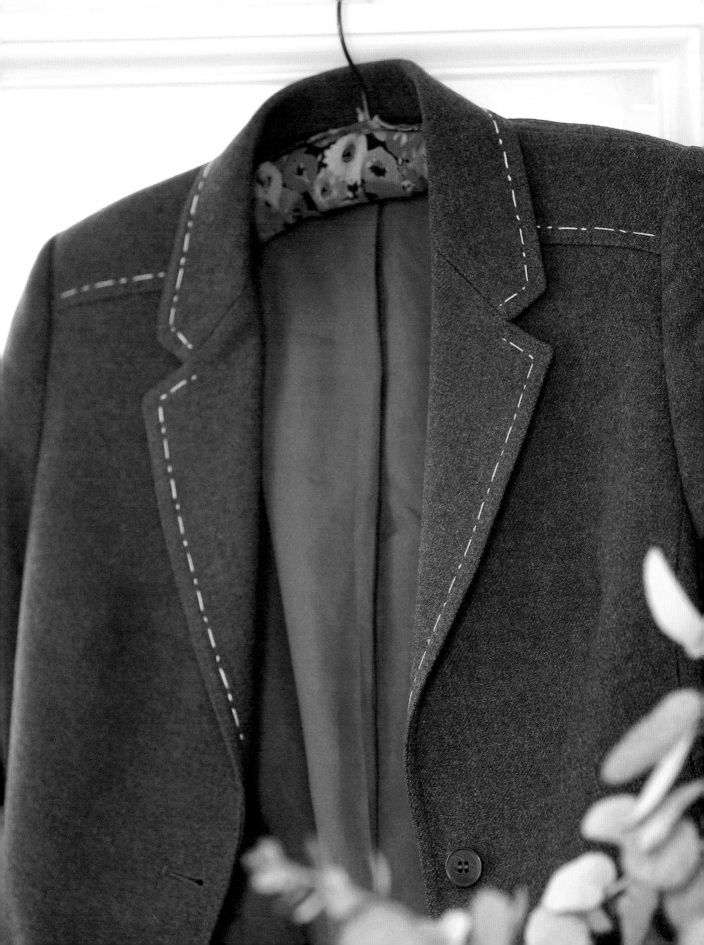

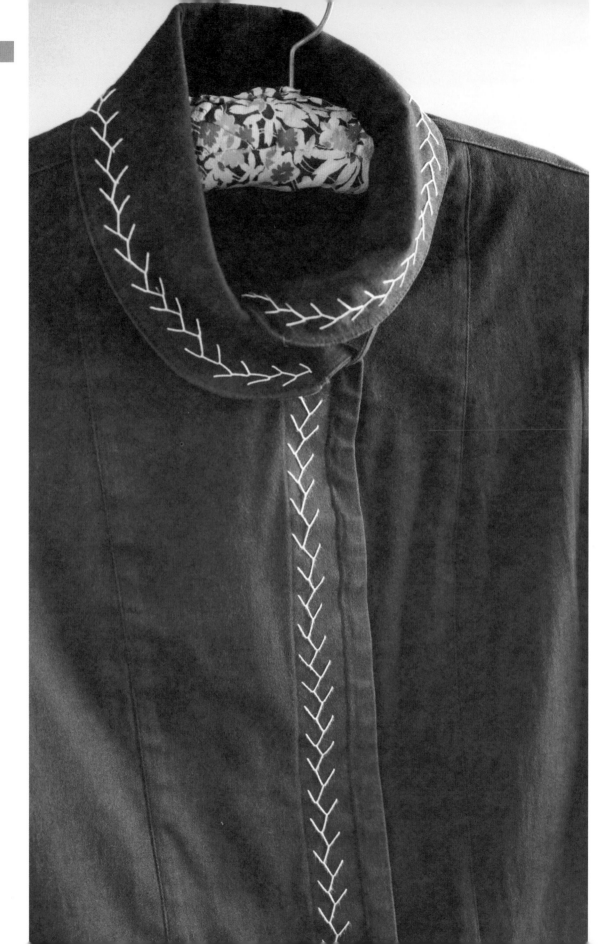

Although I studied fashion embroidery, I am not a hand embroiderer by training. But I love the effect of hand stitching and the fact that you create something entirely personal with it. It is a smart move to limit stitching to simple designs that can be executed with some degree of professional finish!

Feather stitching

This plain black cotton summer jacket was a great favourite of mine. I began to long for something with a bit more distinction, however, so I had the idea of using feather stitch to dress up the collar and the front of the jacket. Actually, I must confess that this design was inspired by Janet Haigh (whose illustrations you can see on the pages of this book). She used herringbone stitch in white embroidery thread to make similarly decorative detail on a jeans jacket, on the yoke, the pocket, and around the hem.

The jacket I decorated is asymmetrical and feather stitch is a curiously spiky little stitch, so they seemed to go together perfectly. Picking a monochrome contrast was just right for this design, which has a naturally simple elegance. I liked the idea so much that I decided to reverse it, and used black feather stitching on the cuffs and collar of an Edwardian-style ruffled white blouse, turning it instantly into something much more contemporary.

Feather edging for a jacket...
This simple black cotton summer jacket (above) gets a lift with neat asymmetric feather stitches in white, running around the collar and down the jacket front (opposite). Feather stitch looks complicated but is actually one of the easiest embroidery stitches to work (see page 139).

...and for blouse sleeves
And the same idea, but in reverse (left), with double feather stitches this time, worked in black on the white ruffled cuffs of an Edwardian-style blouse.

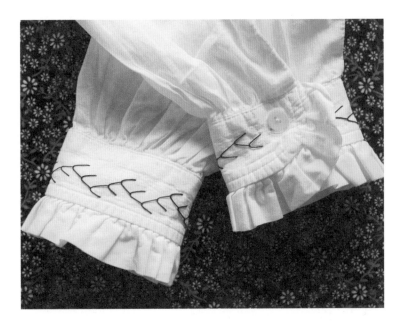

EMBELLISHING BUTTONS

If you like the idea of adding some subtle decoration to plain garments, you can create great effects with a little easy hand embroidery, from simple long and short stitches on a jacket (see page 45) to little decorative details, such as sweet little hand-embroidered, fabric-covered buttons. Cloth buttons can be hand stitched with no trouble if you cover your own (see pages 50-51 for how to cover buttons).

Embroidered buttons

A version of simple chain stitch, lazy daisy stitch is the easiest thing in the world to work (below). You just need a crewel embroidery needle and a length of embroidery thread. Pick a thread that suits the fabric you are embroidering: a thick thread for wool or tweed, a silky one for cotton or satin.

Buttons galore

Here are just a few ideas for decorative buttons. Lazy daisy stitches nicely accentuate the button shape (near right). For contrast, use simple, brightly coloured fabric buttons on a plain garment (opposite, top). For a more subtle look, cover the buttons in pert French knots. (See instructions for lazy daisy stitch and French knots on page 138).

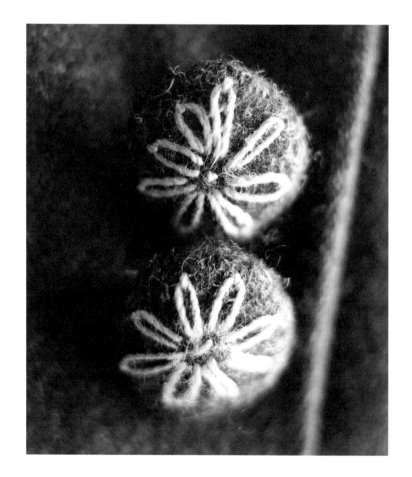

Alternatively, embellish cloth buttons with French knots (below) or little cross stitches, using fine wool or heavy silk thread. A little hand embroidery on buttons adds a bit of contrast to a plain jacket and a really personal touch that looks far more labour-intensive than it actually is!

Floral buttons

You can cover some metal buttons with pretty fabric prints, perhaps using a different motif from the same print for each button. I jazzed up a plain cream cashmere cardigan with buttons like this (right).

Textured or beaded buttons

To make textured buttons for eveningwear, cover them with lace or sheer fabric laid over an opaque one. You could also add beads or diamante studs to the fabric before covering the buttons.

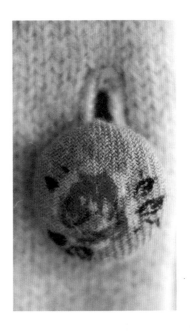

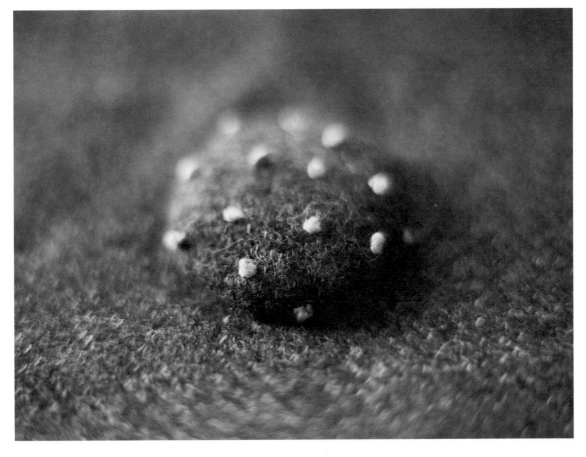

Making embroidered buttons

To make embroidered buttons, first purchase the raw materials. You will need a button kit, fabric with which to cover the button, a needle, an embroidery hoop, scissors, a water-soluble pencil, and your chosen embroidery thread, which could be wool or silk, depending on the style of button chosen.

A covered button kit comes with a metal button top and a metal snap-on base. You cover the button top with a circle of fabric cut larger than its circumference, then snap the two parts of the button together (see the instructions right for the French knot buttons).

Button-kit buttons come in various sizes, from truly tiny ones, which are a bit fiddly to make without a special tool to snap the button pieces together, to big ones, which are easy to make by hand and can also serve as brooches.

How to make buttons with French knots

First, using a water-soluble pen, mark the button circumference on the chosen fabric, adding an extra 2cm (¾in) all around for tucking into the button teeth. Then tightly stretch the marked fabric onto an embroidery hoop.

Cover the fabric circle with French knots or other embroidery stitches (below), leaving the extra 2cm (¾in) of fabric around the edges unstitched.

Remove the finished embroidery from the hoop and cut out the circle (top right). Stretch the embroidery over the top of the metal button top and tuck the edges of the fabric into the back of the button, so that the teeth grip the fabric tightly (bottom right).

Finally, snap the button base onto the back of the button, slipping it over the button shank.

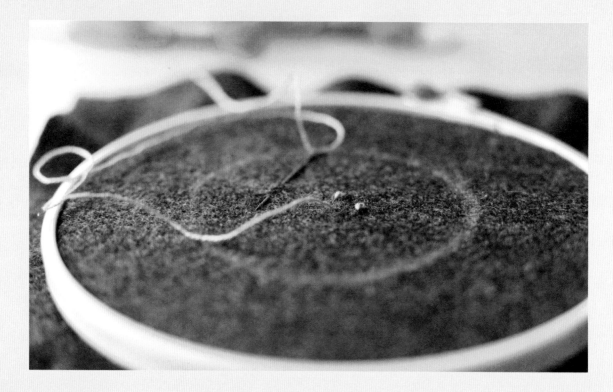

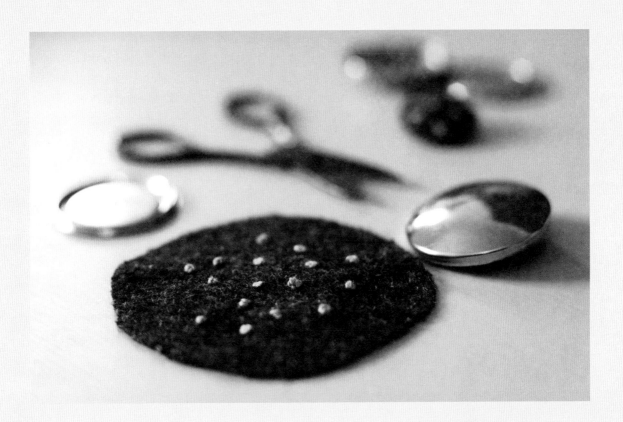

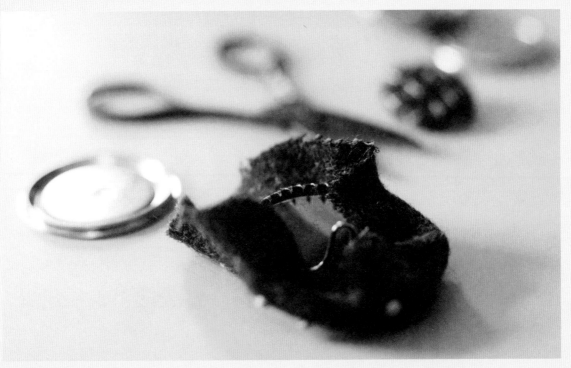

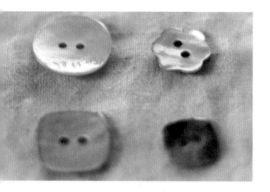

Pearl buttons

I have a collection of different sizes and shapes of little pearl buttons (above) and use them as a decorative addition to blouses in mismatching sets.

COLLECTING DECORATIVE BUTTONS

Buttons have always fascinated me, and I love stores that sell all kinds of speciality buttons. Unfortunately, they can be expensive, so I try whenever possible to look for great buttons on charity-shop garments, buying them occasionally just because I want the buttons!

There is a whole host of decorative ideas using buttons, but it is important to pick the right types of button for the project in mind. Nothing can improve an inexpensive shop-bought garment more than changing the buttons, whether by covering your own and embroidering them (as shown on pages 48–51), or by paying for much nicer ones. This is not a big outlay if your original garment was bought in a charity shop for a song or in a sale.

Another good idea is to change a set of matching buttons on a cardigan or jacket for individual ones in different colours, or different shapes in the same colour range. Or adorn the waistband of a pair of trousers with a line of assorted buttons like I did (below).

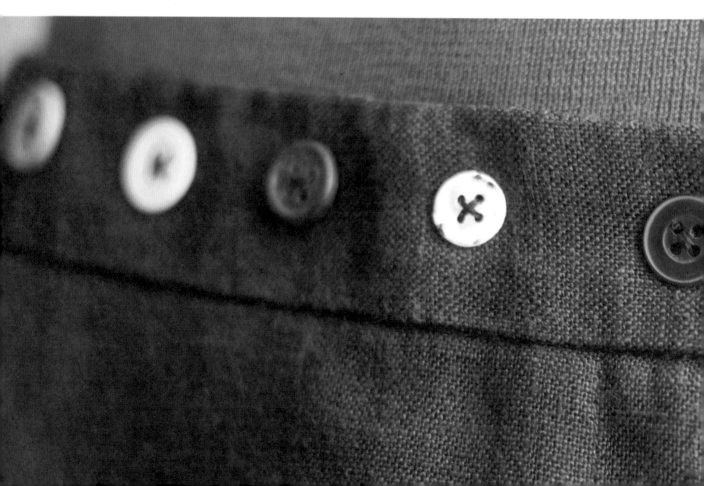

I also dyed a white blouse a pretty shade of mauve, then added dolly-mixture coloured dyed pearl buttons to it, for a great eclectic touch (see page 26 about dyeing buttons).

Sewing on buttons

When sewing on buttons, you could use coloured embroidery thread to make a feature of the stitching, or even use tapestry wool yarn on larger buttons.

Always remember to sew on the buttons securely, though (see page 134 for instructions for how to sew on buttons properly). And if you are adding buttons to a suit, make sure you wrap thread around the stitches under the button so you can push it easily through the thick buttonhole.

On very fine or knitted fabrics where there may be some strain on the buttons, it pays to attach an additional small piece of fabric to the wrong side of the garment and stitch on the button through it . This will prevent the garment from tearing.

Button-decorated waistband

A collection of buttons of similar, but not exactly matching types, makes a great addition to a waistband (below) on a pair of trousers or a skirt. They could be added to a fabric belt, if you prefer.

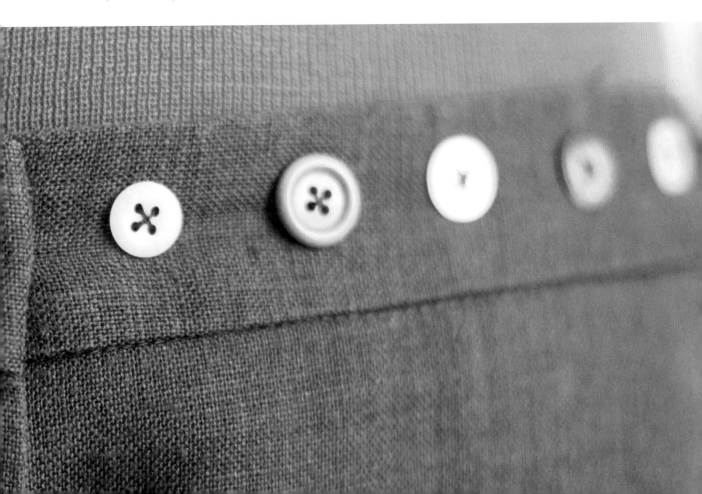

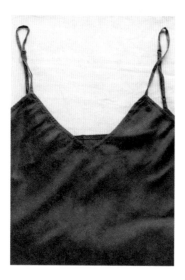

ADDING BEADS AND GLITTER

It is surprising just how much difference a bit of glitter makes. It can transform an everyday garment into something really special. I use beads, sequins, and crystals in a range of different ways on very different garments. Snap-on crystals are my favourite glitter because they eliminate the need for any stitching.

Adding a line of snap-on crystals to the neckline of a simple silk camisole is a good way to make a last-minute party top and costs next to nothing. It takes only a couple of hours, if that, to attach them. If you want evenly spaced crystals, however, you do need to spend some time working out the pattern. As the designs here show (right and below), you can devise all sorts of interesting groupings. It pays to emphasize the lines of the garment, for example by following the neckline, or by edging a collar or even embellishing the narrow shoulder straps.

Beaded tops

Give a plain silk camisole (above) a lift by snapping on crystals in staggered rows around the neckline and armholes (far right). (See instructions on page 104.)

Alternative beading pattern

If you want a less time-consuming version, attach a group of four crystals just under the centre of the V-shape and one under each strap (right).

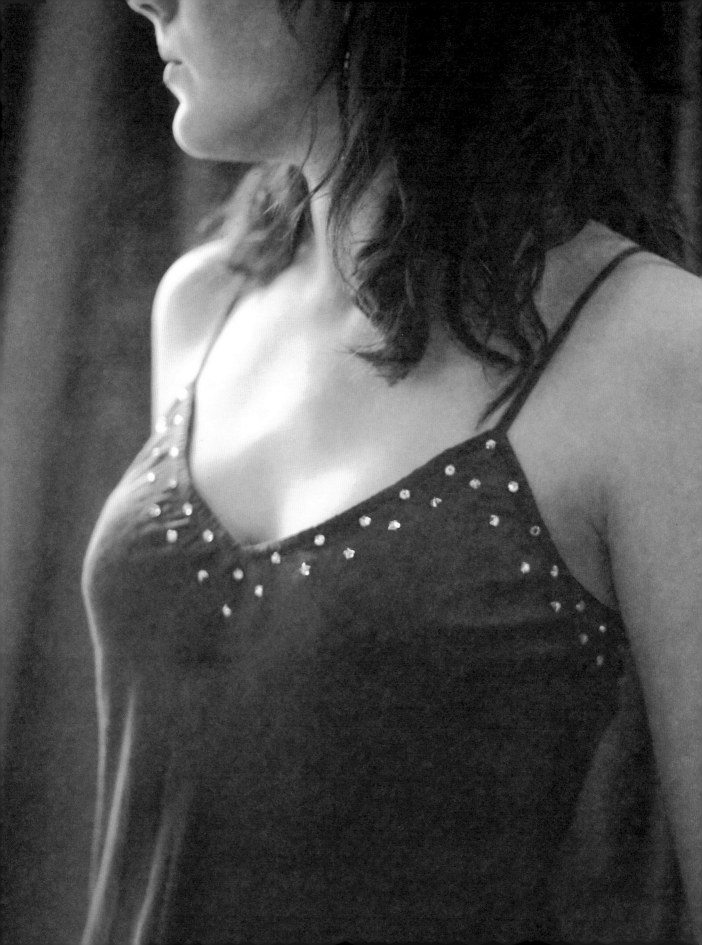

VAMPED UP SHOES

Beads are just great. I am totally in love with them, and collect them in all shapes and sizes, from huge glass ones to tiny little ceramic ones, old-fashioned flapper bugle beads, and bits of jet. You name it, I have it! One of the best sources of nice beads is to use old necklaces, or ones you have that have broken (see pages 76-77).

I use beads in a whole range of ways, as a trim, as a main decoration, or simply as an unexpected glittery bonus on anything that needs a bit of a lift.

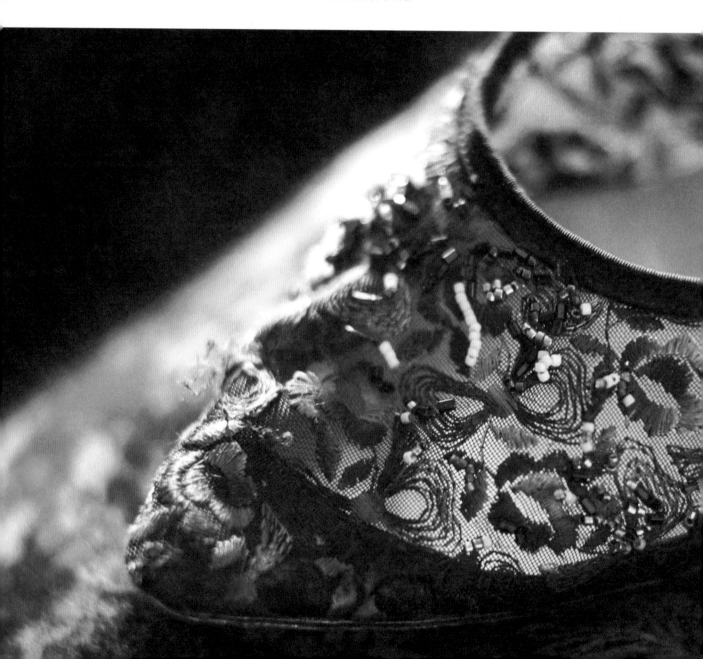

Sparkly feet

It is easiest to add beads to the edge of the vamp on fabric-covered shoes (right and below), as you can't get your hand further inside to stitch them. If you don't have evening shoes like these, bead a pair of espadrilles instead. (See instructions on page 103.)

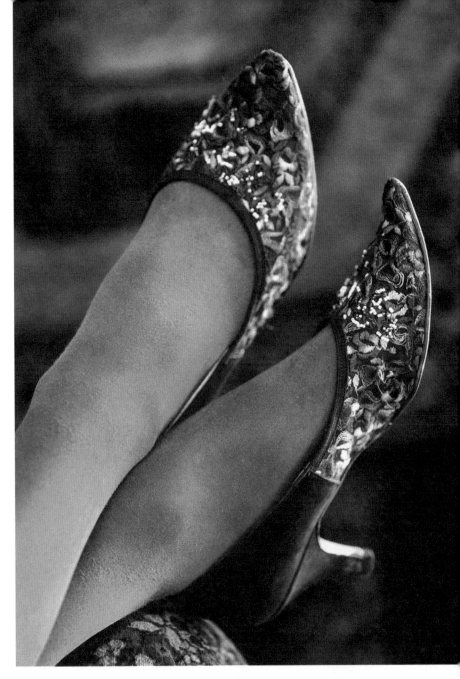

Sometimes ideas just come from nowhere. My friend Lucy had these great patterned fabric shoes that were a bit battered, so she decided to attach a few random beads to the pattern to add a hint of glitter and sparkle (left and above). Hey presto, she had the equivalent of Cinderella's slipper. You probably aren't going to find a similar pair of shoes very easily, but you could certainly apply the principle to a lace collar, perhaps, with just some random arty beading on part of the filigree pattern. The secret here is to stay minimal: don't cover the whole surface, and keep it all a bit irregular.

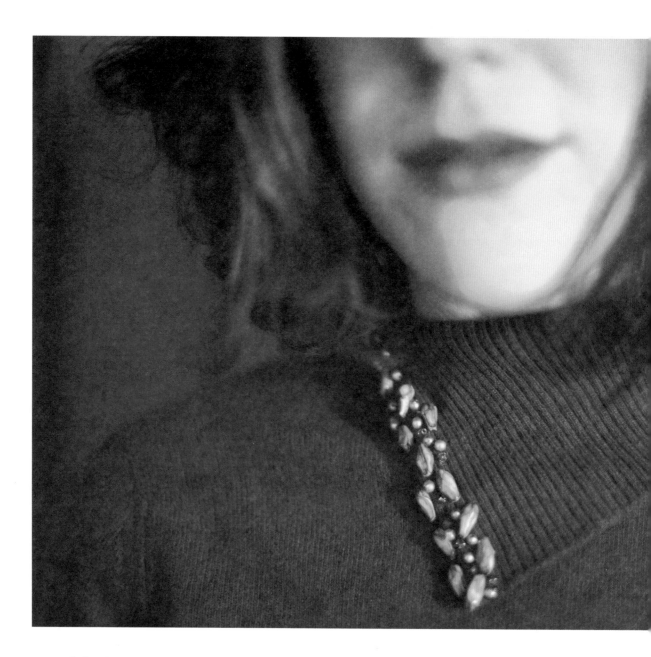

30s-style beaded neckline

These two designs demonstrate a great way to
decorate a plain wool poloneck sweater (above and
opposite). Simply cut the poloneck along the side
seam and neatly bind the wrong side with fabric tape
or machine zigzag the edges. Then stitch the beads
along the edge in whatever pattern takes your fancy.

Small shiny beads work best. A great source of
inexpensive beads are charity-shop necklaces.

I used toning beads for both of these sweaters,
with two different shapes of beads for the green
sweater (above), and smaller, more discreet ones for
the red sweater (opposite). (See instructions on
page 105.)

BEADED SWEATERS

I collect nice cashmere jumpers in classic colours and shapes and buy them from secondhand shops whenever I spot a good one that fits me. Because I like putting unexpected combinations together – adding glitter to wool, for example – my sweater collection is just the kind of blank canvas I like.

It wasn't hard for me to find just the right beads in my workbox to vamp up boring cashmere polonecks (left and below). I took an orange sweater, a deep red one, and a dark green one, and varied the beading style with each, using the beads to decorate only the edges of the collars. This style has a nice 30s feel to it, I think.

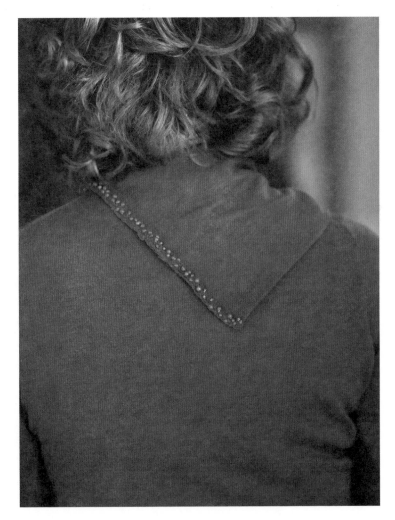

Flower power

I used an old fabric flower for the decoration on this cardigan (above). I pulled the flower apart, then scattered the petals, which were different sizes (right), along one neck edge of the cardigan (opposite), adding a few snap-on crystals to finish it off. (See instructions on page 108.)

APPLIQUÉ DECORATION

Over the years, I have increased my collection of cashmere sweaters and added many others in merino or botany wool. I have found some wonderful colours, but the styles are not always very exciting. If you hunt around in charity shops, you will find any number of plain sweaters in slightly different styles – round necks, polonecks, V-necks, round-neck cardigans, and V-neck cardigans, in short or long sleeves. They seem to be crying out for some sort of personalized decoration, so here is one idea for making them more interesting, using beads and flowers.

You don't have to copy exactly what I have done (in any case, you probably won't find exactly the same colour), but you can use the idea to experiment with your own finds.

Occasionally, I find a jumper in a charity shop with a couple of small holes, and if they are in a place where I could apply a decoration, this is just what I do. One of the most effective forms of decoration is to scatter flowers along one side of the neck on a cardigan, or perhaps around the line of a V-neck. For the floral appliqué, just take apart an artificial fabric flower and sew the

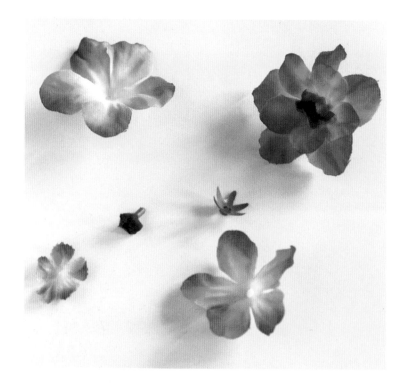

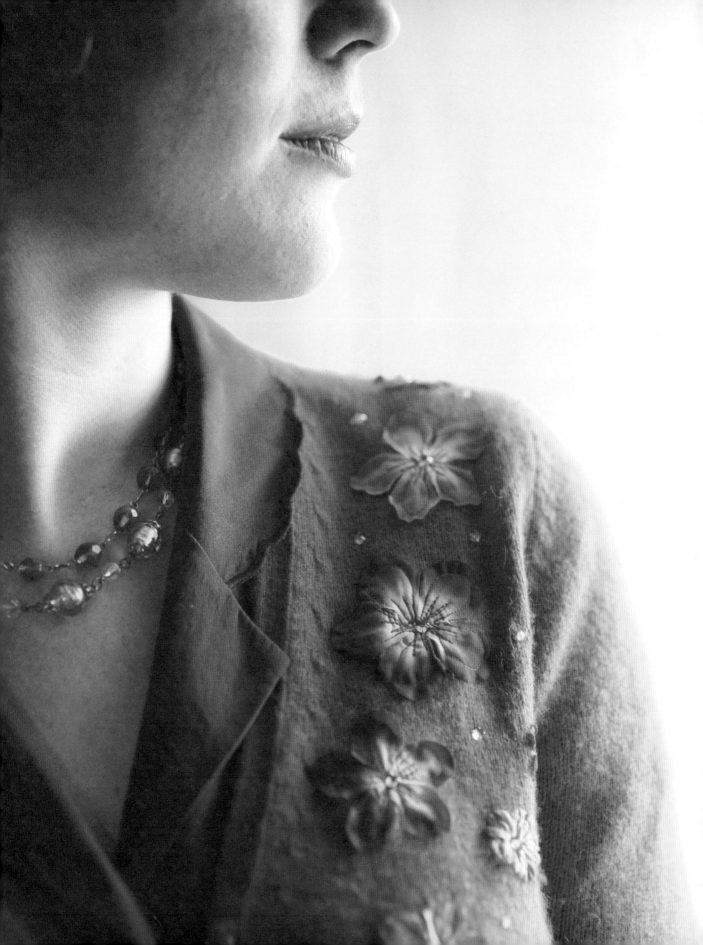

petals individually to the sweater front in a random design.

You can also make your own appliqué motifs from scraps of floral print, as I did on a camisole (left and below), by simply cutting out the flower motifs from the print. You can machine zigzag stitch a single motif to a garment, or a little row of them to a skirt yoke or waistband.

Hand embroidered touches

You can also hand embroider the appliqué. After I had machine stitched the petals to my camisole, I decided to jazz up the flowers by adding a few simple straight hand stitches in a bright orange silk embroidery thread. If you are good at hand embroidery, though, you can be more adventurous and perhaps add a few stems or tendrils to the design.

Another good idea is to embroider around any buttonholes, using either buttonhole stitch in a contrasting coloured thread or stitching a little design to complement your flowers.

Flowery camisole

Taking the same design idea as on the cardigan on page 61, I have added petals in a row along the top of a plain camisole (left), transforming it very easily into something prettier and more personal.

Hand-stitched decoration

Just a few simple hand stitches in bright orange thread give the flowers a more three-dimensional appearance (below).

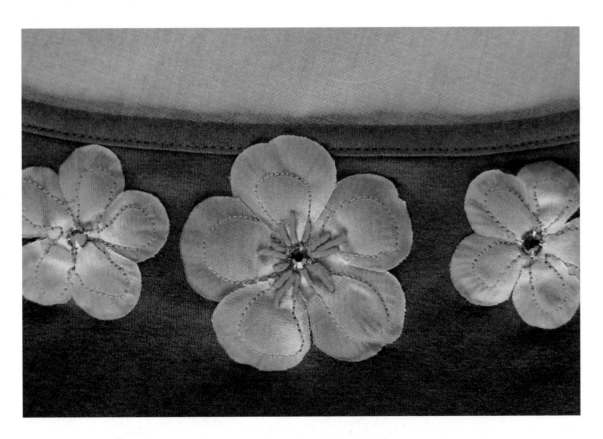

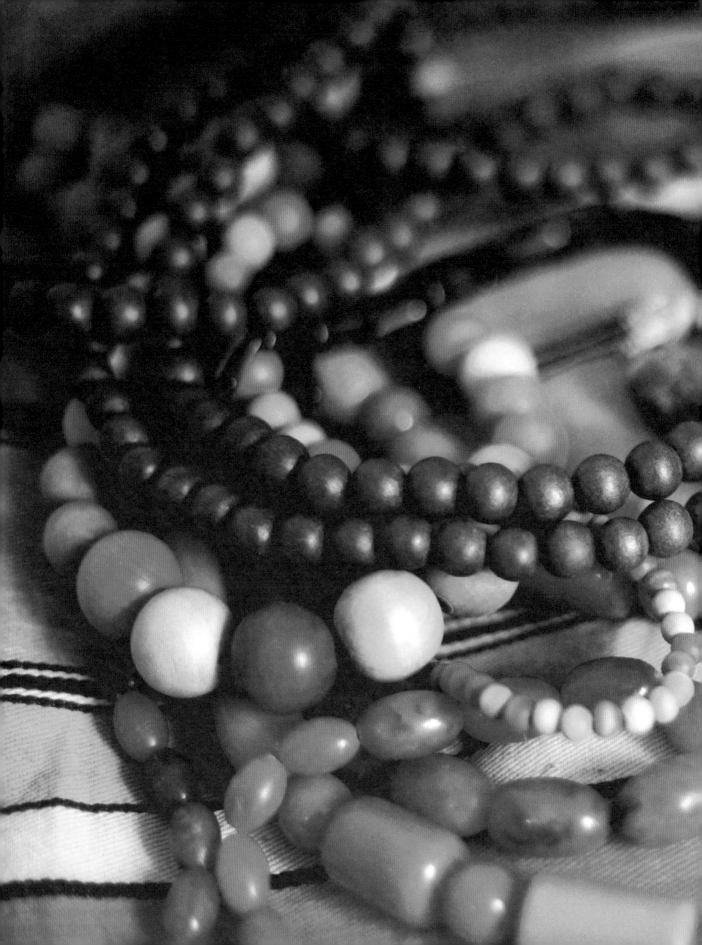

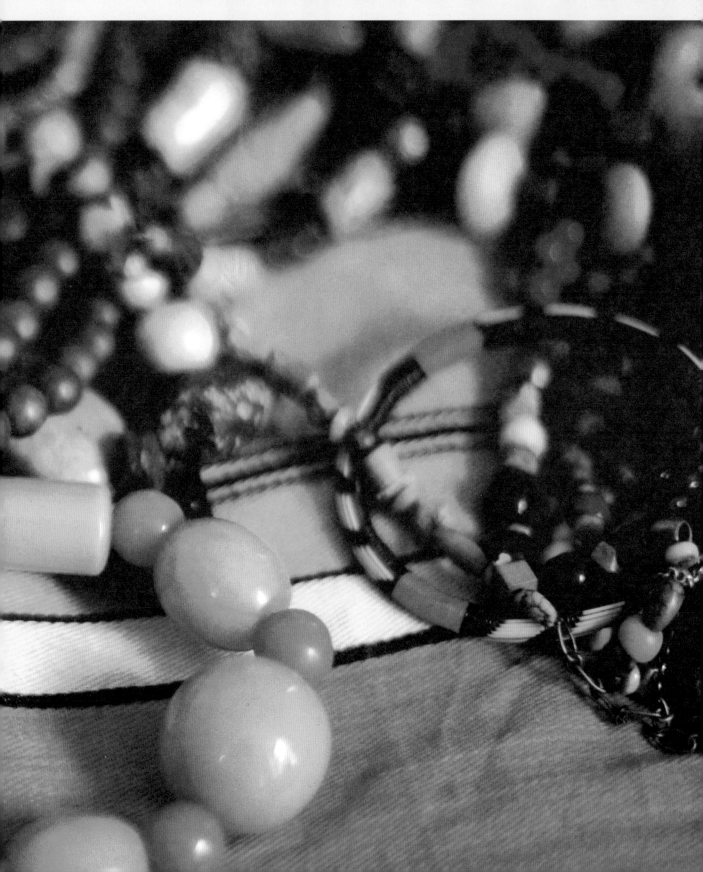

Before you start

• •

If you are prepared to do a little bit of cutting and stitching, you can change your wardrobe more dramatically. This applies not just to clothes, but to bags and old jewellery, too. There is really no limit to the scope, apart from how much effort and time you want to spend in the process. If you are like me, that is probably not a lot! What I look for, and enjoy, is finding clever ways to use something most other people would overlook.

Among the things I revamped for this chapter are a baggy old leather skirt that turned itself into a great bag and a lace tablecloth that was just great for a flamenco-style skirt when dyed a jazzy red. What you need to look for, as always, are great fabrics that can be recut into new shapes. You can so often find secondhand designer-labels in fantastic fabrics, but in styles that are no longer contemporary.

It is important, though, that you know what you cannot do in terms of minor changes of shape. It is not difficult, for example, to shorten a skirt, dress, or a pair of trousers, and I give some basic instructions at the back of the book for these routine alterations (see pages 132-133). But as soon as you want to start drastically taking things in or letting them out, then you usually need to know a whole lot more about dressmaking and would be better off getting someone to do it for you or following a specialist book.

As you might expect, the ideas in this chapter cover some of the concepts from the first two chapters, so in addition to changing shape, some of them have changed colour or incorporate some extra decoration.

Lucky accident!
A plain felted white pure wool
poloneck sweater (above) with
the front cut open, the collar
removed, and the edges rounded
off made a great bolero (far right).
(See instructions on pages 110-111.)

Finishing detail
Embroidering the edges with big
black wool yarn running stitches
emphasizes the shape of the
bolero (right). Add a matching
brooch to turn the bolero into a
great evening cover-up.

BOLERO FROM SWEATER

If you have inadvertently shrunk a pure wool sweater in the wash
(as I have done too many times to count), and it is now too small for
you, you can turn it to your advantage by cutting it into a smart
bolero. The open front gives you at least another three or four inches
around the bust.

Once wool knitting has shrunk, it becomes matted and will no
longer unravel or fray, so you can cut your sweater with abandon. If
you cut the shrunk sweater down the front, you can turn it into a
really great bolero, rounding off the edges at the hem and trimming
the sleeves.

You can then decorate the newly created top with whatever you
fancy. The one I made here has been decorated with super-large
stitches around the neck, front edges, hem, and cuffs, in a
contrasting colour. But you could just as easily appliqué the front,
using any of the ideas on pages 60–63 or add a lacy edging like on
the camisole on page 43.

The sweater was a simple stocking stitch that when shrunk
created a flat, semi-felted surface ideal for decoration. With more
textured knitted or crocheted garments, the felted texture alone
would be decoration enough.

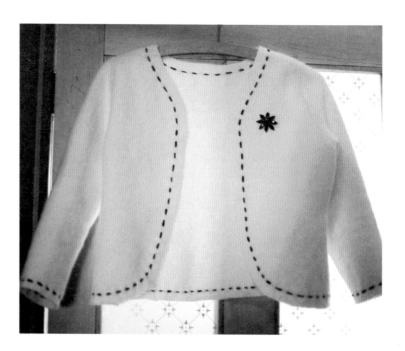

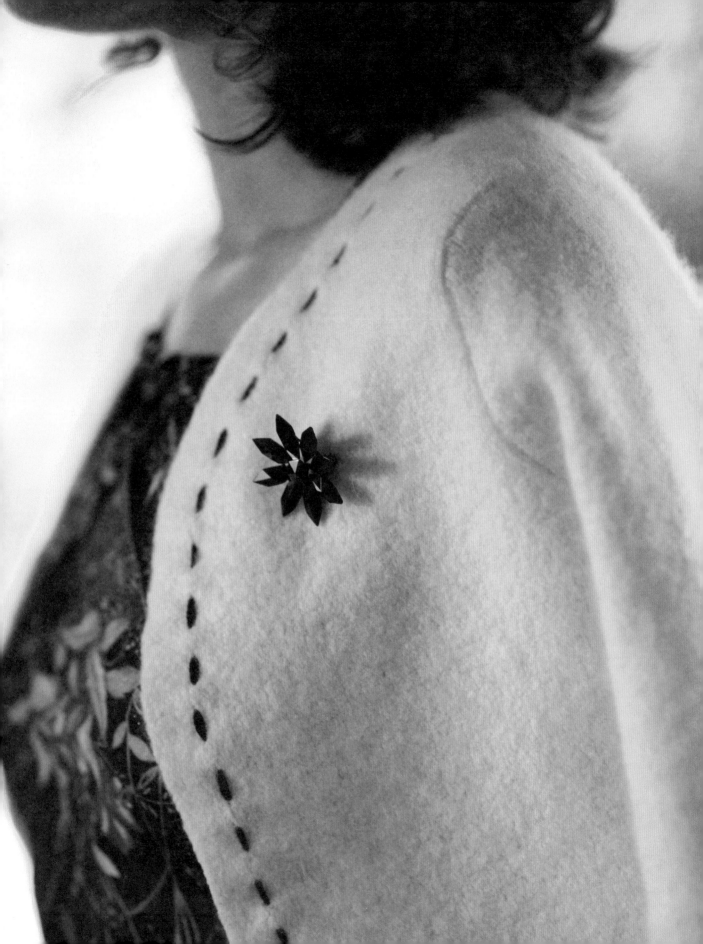

LEATHER BARGAINS

You can sometimes find leather or suede skirts at bargain prices in charity shops, or you may have an old one of your own that you no longer wear. Either way, they provide great raw material for a fantastic new bag that looks really expensive, but actually costs next to nothing. What is more, it's not difficult to make.

Don't be put off by the fact that you are working with leather. For a start, it cuts really easily with a pair of sharp dressmaker's scissors, and – a great benefit – it doesn't fray. All you need is a sewing machine that does straight stitch, a strong sewing thread (such as button thread) and a specialist leather sewing-machine needle.

For reasons of economy, leather skirts are often made in several pieces, as the manufacturers use up leftover cuts from bigger items such as coats. For the bags shown here, I have used the natural seam lines of the skirt to add interest to the front of the bag, positioning the join fairly low down on it for the maroon bag and across the middle for the black one.

The long rectangular shape looks smart. I made handles from a wide band of leather and attached them fairly close together, then overstitched them for strength. If the skirt doesn't have seam lines you can use, then you could always machine embroider the front before you stitch the front and back together. Or patch different leathers together for a more lively look.

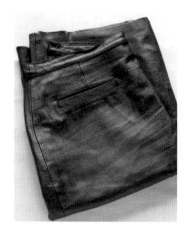

Old skirt to new leather bag
This well-used maroon leather skirt (left) gets a new lease of life in the form of a really neat leather shopper (near right). The seaming on the skirt front turns into a feature on the bag front. I gave a black skirt the same treatment (far right). (See instructions on pages 112–113.)

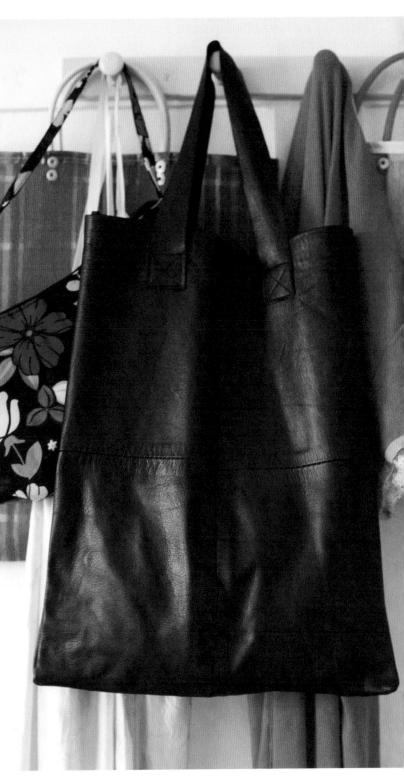

SILK SCARF HALTER TOP

You can find any number of great square silk scarves secondhand, or you may have a few of your own that you no longer wear. I discovered that you can turn them into fantastic evening or summer tops, literally in minutes, by folding the scarf in half diagonally, then turning over one corner and stitching it down. Either a necklace or a pretty ribbon can be used for the strap, and the scarf ends are tied neatly around the back.

For the tops shown here and on the following pages I used silk scarves approximately 1m (39in) square, but you should use the size that fits you.

The best scarves to choose for this project are ones with a clearly defined graphic design. Stripes work well as they look good seen on the diagonal, which is exactly what happens when they are folded diagonally in half. Big flowery prints also look good, and black is always great for sophisticated eveningwear.

You can ring the changes with the kind of necklace you use as the strap. I chose some delicate painted beads to go with the stripy top, as they picked up one of the colours in the stripe pattern. Try to ensure that the style of necklace suits the design of the scarf print, and complements it without overwhelming it.

If you want a less dressy version, a simple large cotton scarf could be used to make a similar top. Use coloured fabric tape for the halter strap. This would be perfect for the beach, with a pair of denim shorts, cut down from an old pair of jeans.

Slinky tops
Two great silk scarf designs, one striped (top) and one floral (above), turned easily into two different versions of the same halter neck top (right and far right).
(See instructions on page 109.)

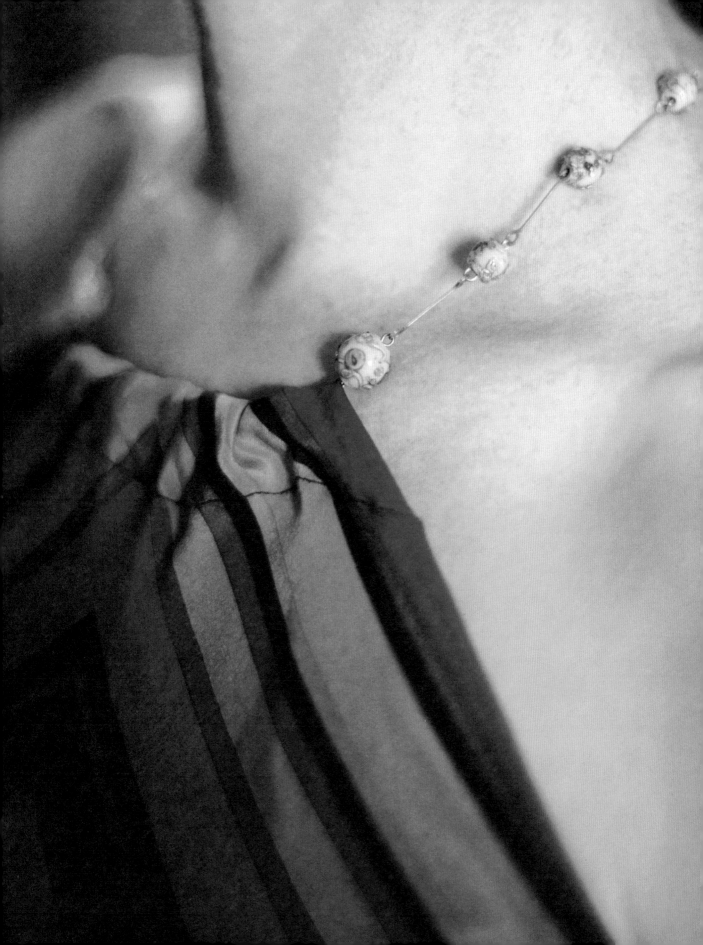

Back detail

The great thing about this simple halter top (right) is that it comes neatly to the waistline at the front, and just ties at the back in a simple double knot. Pin a safety pin to the knot if you are worried about the knot coming undone.

A floral scarf I had made the perfect halter top to go with a long black satin skirt (right). Because the pattern on it is quite strong, I decided to opt for a simple ribbon for the halter strap, tied at the neck. As you can see, the scarf itself ties at the back in a knot. Being silk, the fabric unties relatively easily, so the only problem is if some wit decides to untie it for you! If the prospect of being unveiled unexpectedly alarms you, then tie the knot at the back and fasten a large safety pin through the knot where it won't be seen.

You can make the channel through which the ribbon or necklace is threaded as narrow as the strap to be threaded or wider if you want to allow a choice of ribbons for different occasions.

Another version that works well with cotton or fine wool fabrics is to turn over the top corner of the folded scarf in the usual way, but to the right side rather than the wrong side of the halter top. Fringe the edges by pulling out the threads to a depth of an inch or so. Then stitch the channel for the halter.

If this top is too revealing, then make yourself a matching bolero like the one on page 68 to wear over it. A plain black sweater with white stitching would make an ideal evening cover-up.

Pretty in pink

Another version of the top features a fringed neckline (left). For this, you need to pick a cotton or fine wool fabric that will allow you to pull threads out easily to make a fringe.

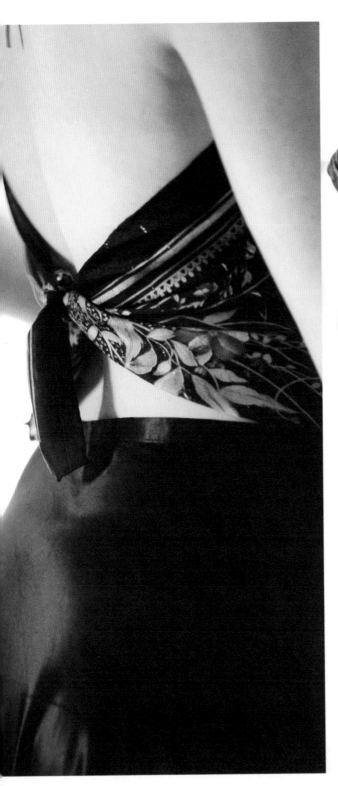

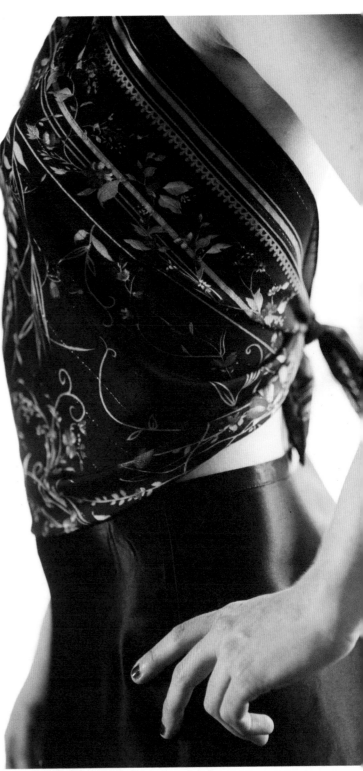

New necklaces from old

If, like me, broken costume jewellery has left you with an assortment of beads, you may already have just what you need to make new necklaces from old. Otherwise, try picking up inexpensive but interesting necklaces in charity shops and salvaging a few of the nicer beads.

Although there are complete jewellery kits available that include special wire and clasps, I found it was quite easy to devise a system of stringing using only strong button thread and a needle.

You can employ your creative flair in deciding which beads to put together and what spacing you want between them.

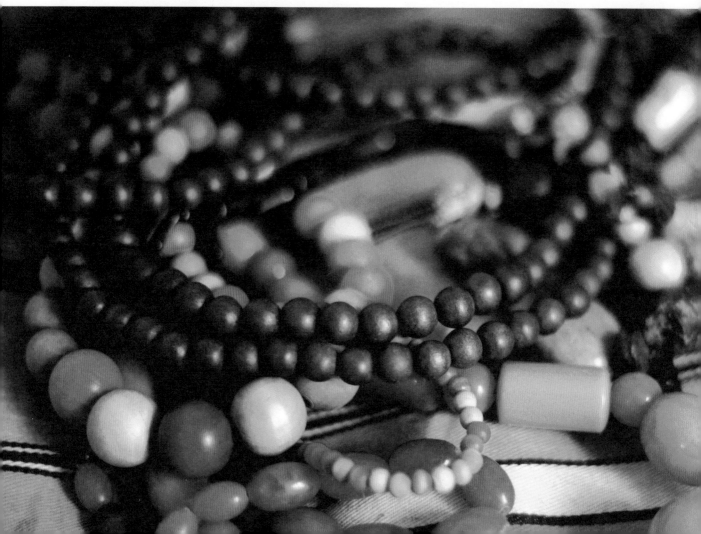

Here is the method used for the very simple necklace that my sister made for me (see page 79):

Collect together your beads, brown button thread, and a needle. Make sure the needle has an eye large enough for the strong thread, but not so large that it won't go through the beads. Decide on the form you want the necklace to take and the order of the beads.

Next, thread the needle, tie a large knot at the end, and start by stringing on the first bead.

Then pass the thread through the first bead a second time to secure it firmly to the thread. Do the same with the remaining beads. Finish by making a loop at the end of the thread through which the first bead is pushed to fasten the necklace.

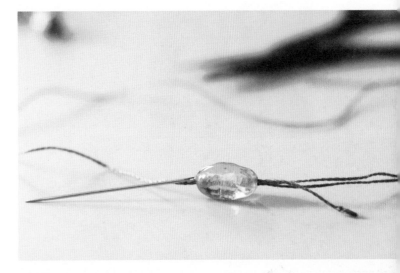

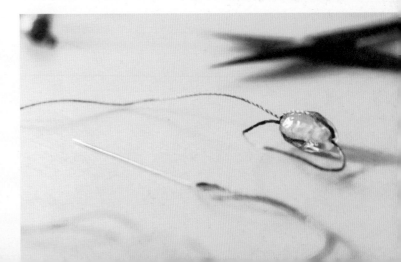

Old brooch to new buckle

An old-fashioned big paste brooch (below) makes a great new buckle for a simple belt made from a long silk scarf. Simply pull the scarf through the buckle fastening and wrap around it once or twice to fasten it.

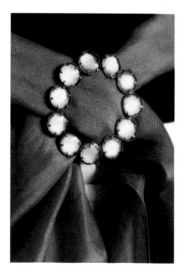

Recycled beads

These little necklaces (right and far right) were made using the techniques explained on pages 76-77. Stringing them together using a needle and thread is really easy to do and involves no special equipment.

NEW JEWELLERY FROM OLD

Using old jewellery in new ways is as satisfying as revamping clothes. It is really easy to string your own beads (see pages 76-77), whether to make necklaces, bracelets, or earrings, and you get the fun of creating your own designs into the bargain. You can play with the positioning of the beads, mixing large and small ones, but on the whole, it is often best to keep to one type of bead for necklaces to achieve some symmetry of design – use all wooden ones or all glass ones, for example. An exotic mix is also attractive and very now!

Other jewellery ideas

Another good source of inspiration lies in old brooches and clip-on earrings. You can turn a large brooch into an eye-catching belt buckle, simply by threading a silk scarf (or two) through it. Old clip-on earrings make a great fastening at a V-neck. You can also put a pair of them at the corners of a sweetheart neckline, or attach them to a pair of evening shoes (see page 34).

Simple jewellery can even be made from old clothes. Cut out a flower from a fabric print, stiffen it with felt using fusible bonding web adhesive, and zigzag stitch around the petals. Glue an old brooch clasp onto the back of it. You can even bead the centre.

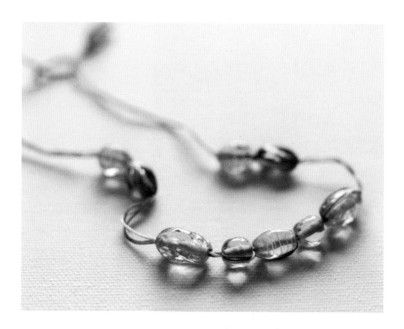

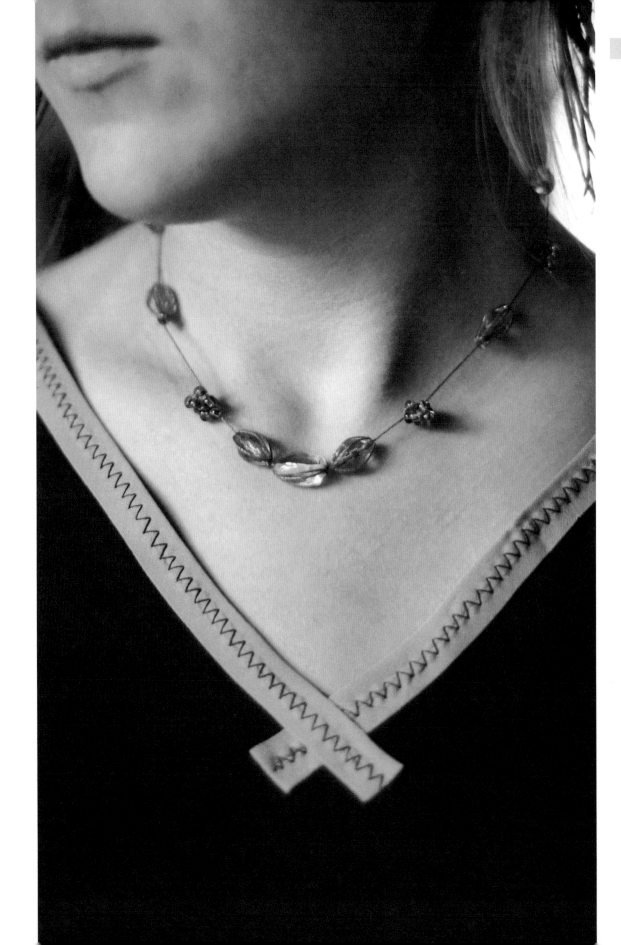

FROM SKIRT TO SCARF

Scarves go in and out of fashion, as indeed do the ways that you wear them. Long ones make handy belts, too.

If you enjoy doing a bit of simple stitching, then why not make a few scarves of your own? You can find skirts in charity shops that are in truly great fabrics, but in styles that you would not be seen dead wearing. So, if you come across some fantastic silk prints, and can pick them up for a song, then why not turn them into a scarf or two? You can always give one to a friend. Depending on the size and style of the skirt (or dress), you could make a rectangular or square scarf. Long narrow scarves are more fashionable, much easier to wear, and more versatile. You could make a halter top from a simple square (see pages 72–75).

If the print is a strong graphic one, the scarf probably needs no further embellishment, but if you pick a smaller print, you might like to add a fringe or some dramatic snap-on beads.

Printed skirt to snazzy scarf
This old-fashioned pleated patterned skirt (above) is the ideal raw material for a narrow muffler-style scarf (right). Use the surplus fabric, too, to make a square for a halter neck top (see pages 72–75).

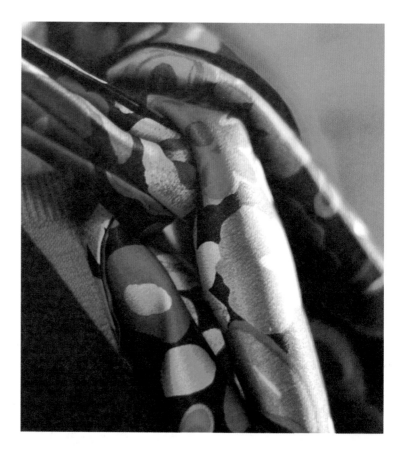

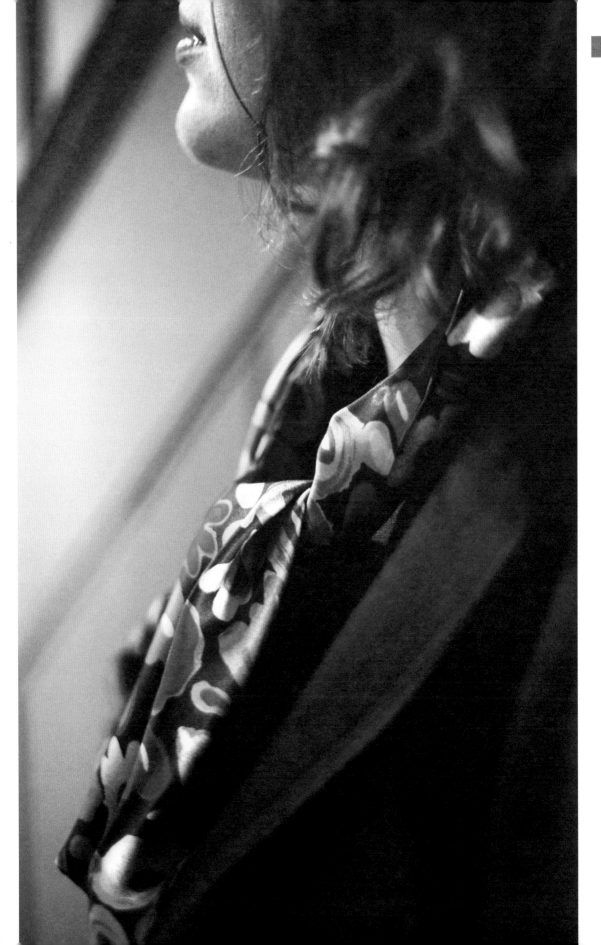

FROM SKIRT TO BELT

I used a big floral cotton print from an old skirt (left) to make a bold cummerbund-style belt (right). The simple belt fastens at the back or front with matching ribbon ties. You can tie it around the waist or at the hip, according to the length. Depending on the type of fabric used, you might need to stiffen the belt to give it more body by adding interfacing to it when sewing it together.

All sorts of different fabric prints would work as a belt, although the more graphic the design the better. Big polka dots would look especially smart.

Embroidered versions

To make a floral belt more individual, you can always embroider over the print, with machine or hand stitching, or bead around the flower motifs.

Alternatively, you could make a similar belt from a plain wool fabric and appliqué flowers cut from a printed wool fabric onto it, machine stitching them in place (see page 63).

You could adapt this idea, too, to create a hand- or machine-embroidered border for a skirt.

Floral print belts

I doubt if I would have wanted to wear the skirt (above) that I found in a charity shop, but I liked the splashy floral print. It turned out to be just right for a wide belt tied with ribbons (far right). For an alternative version (right), made in the same way, one of the flower motifs can be beaded in matching colours to give it more impact. (See instructions on pages 114-115.)

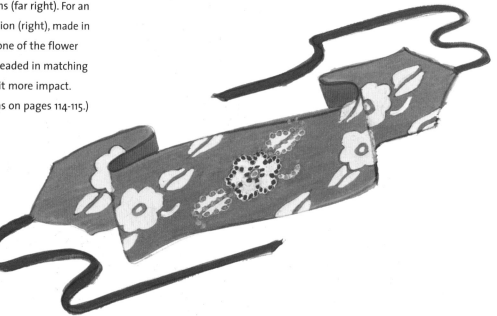

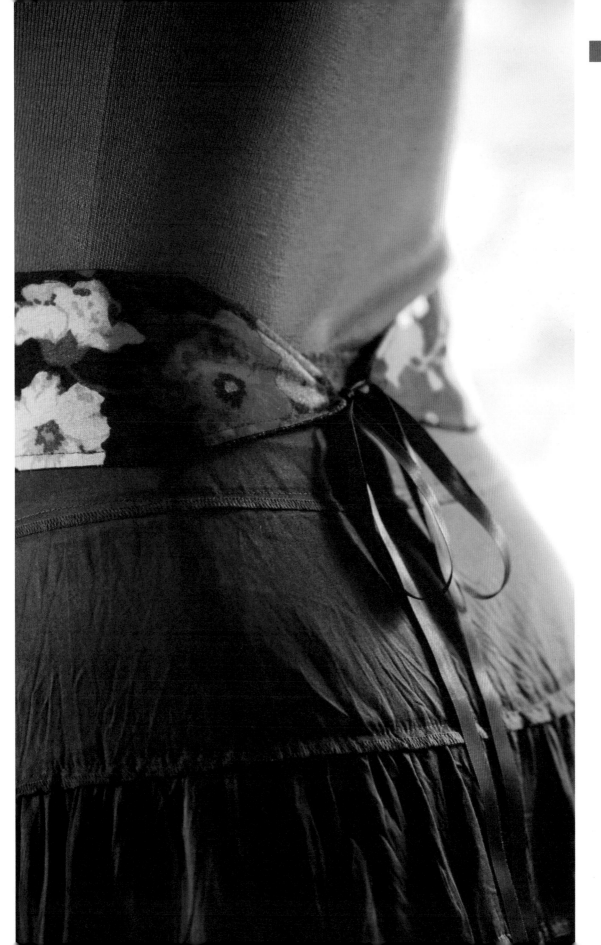

LENGTHENING A SKIRT

Many times, I find a skirt that I like but it is just a tad too short for my taste, or maybe it is the right length, but a bit too boring. Here is the answer! Add a border to it at the hem. You don't need to be an expert seamstress to do this, but beware of the skirt type. The easiest ones to add to are those that have no pleats or splits.

When adding a border, pay attention to the overall shape and style of the skirt, to make the border appear to be part of the original design. For example, I attached a border in a small-scale black-and-white floral print to a long plain black skirt (right); the print picks up and complements the skirt colour nicely and the border is narrow so as not to overwhelm the skirt style.

If you wish, you could make the border more decorative by adding ricrac or braid (perhaps in a contrasting colour) to emphasize it. If you stitch a plain white border to a black skirt, sewing lines of black ricrac on the border to pick up the colour of the main garment would help to unify the design.

Borders added to short skirts may not look quite right unless you balance the new border with an echoing design element at the waistband, as you don't want it to look as though it has been tacked on as an afterthought. If you made a belt, perhaps, from the material used for the hem border, this would make the whole design look more considered.

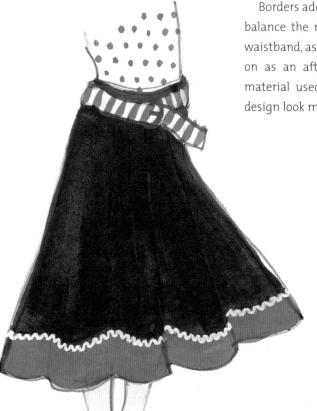

Plain skirt to party number
This satin skirt was both a bit plain and a bit short (top left), so I added a black-and-white floral border to the hem, both to lengthen it and give it a bit more interest (right). A similar border, using plain fabric and contrasting ricrac, looks equally good (left). To give the design unity, make a fabric out of fabric in colours that pick up those in the border.

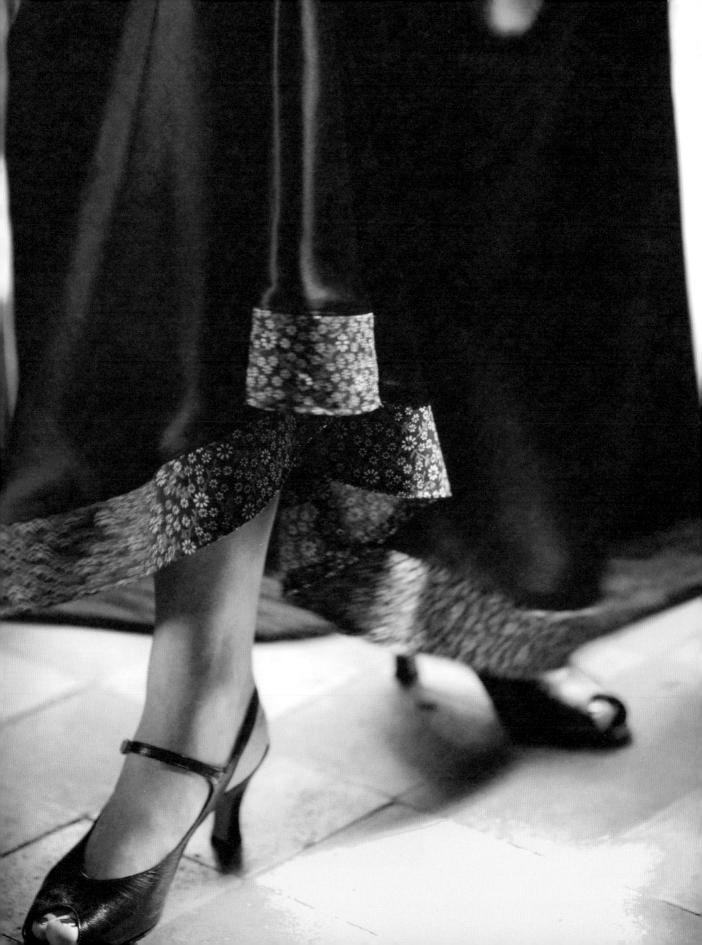

- - - - - - - - - - - - - -

Remodelled trousers

A pair of plain cotton trousers
(above) make an attractive pair of
capri pants with the addition of a
lacy trim (far right).

Edging trims

Opt for toning or contrasting
edgings to lengthen hems on
trousers and skirts when they are
too short for you (right). Both lace
and ricrac can be dyed to suit (see
pages 28-29).

NEW CAPRI PANTS FROM OLD TROUSERS

If you have a pair of last season's cotton trousers that you are bored
with, it is really easy to give them a new lease of life as a pair of capri
pants or shorts. The best trouser style for this is one with a straight
leg for capri pants and a slight flare for shorts. Narrow trousers
don't usually look good when cut off short and can be very
unflattering to anyone with a generously proportioned backside! All
you need to do is decide on the style that you want, measure the
required length, and cut off the surplus, remembering to leave
enough fabric to turn under for hems (see pages 132-133).

You can customize a pair of lightweight cotton or linen trousers
with some fancy braid or trimming at the hems, and even dye your
own if you wish. This idea also works well if you want to lengthen a
pair of capri trousers a little, as a deep braid, like the one shown
right, can add an inch or two to the length. This idea can also be
adapted to sleeves that are too short and unflattering.

If you are shortening jeans that have a double seam down the
sides for durability, you will end up with a very bulky hem unless you
cut a small chunk out of the seam hem to avoid too many layers of
fabric; plus. it is almost impossible to machine stitch successfully
over a very bulky seam.

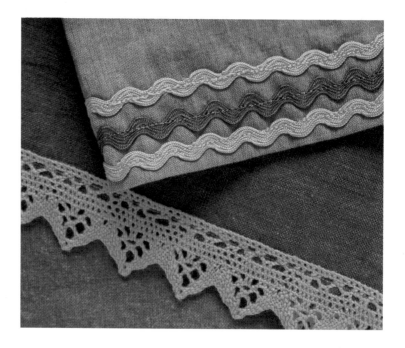

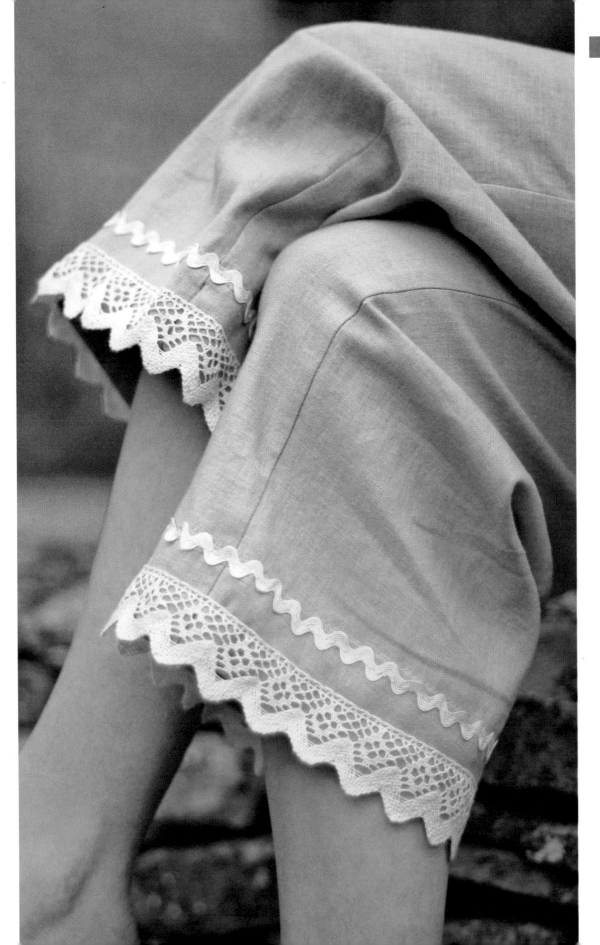

Classic shirt goes smart
This staple shirt style (above) gets
a revamp and a restyle (far right).
The collar has been trimmed with
decorative braid, and the loose fit
is nipped in with small tucks on
the shoulders and below the
bust. (See instructions on pages
116-117.)

Smart gets smarter
If you like the idea of doing some
more stitching, then you could
also revamp the sleeves (right),
cutting them to three-quarter
length, making tucks as on the
body of the shirt, and adding
matching braid around the edge.

OLD SHIRT, NEW SHAPE

You can find any number of shirts as bargains when looking for
secondhand clothes, but the classic long-sleeved cotton shirt is
often unfashionably wide in the body and on the shoulders, too.

With a cotton shirt, if you are prepared to do a bit of stitching,
you can alter the design by making tucks across the shoulders and
corresponding tucks on the body. And, if you fancy your chances as
an embroiderer, you could define the tucks with small running
stitches in a contrasting colour. You can make tucks in silk shirts as
well, but stitching silk is a bit trickier than cotton, as it tends to slip,
so don't embark on this unless you have some experience.

You could also jolly up the collar by adding a trim. If the collar has
a separate collar stand, you can also unpick it, remove the collar, and
restitch the stand to create a collarless Nehru-style top.

To give the sleeves a bit of interest, you can cut them off short
and trim them with the same braid as the collar.

And don't forget the button trick, either! Change the usual plain
pearl buttons for some more interesting multicoloured ones.

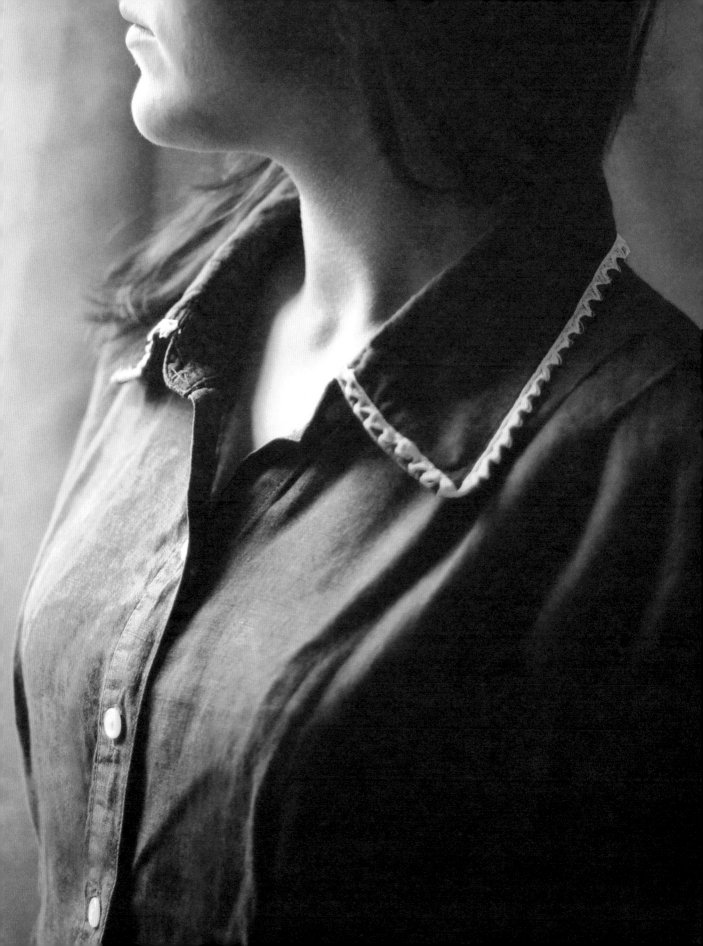

CHANGING NECKLINES

If you have a simple round-neck T-shirt and find the neckline a bit too tight and high, then you can easily cut it into a more flattering and feminine V-neck.

The point of the V is not easy to face neatly, however, as it demands some dressmaking skills. An easy solution is to cover the newly cut neck edge with bias binding or fabric tape.

I created two different looks for this type of neckline. One bias binding I made myself from a fabric strip cut from a floral print (below). For the other edging, I used ready-made bias binding (right). I simply zigzag stitched the binding on top of the raw neck edge, overlapping the ends of the binding at the front. You can either trim off the ends diagonally or turn them under. This transformed my round-neck T-shirts really quickly.

T-shirt transformation
Revamp a plain round-necked T-shirt (above) by cutting a new V neckline. You can cover the raw edge with ready-made bias binding (far right). Just cross the binding at the V point, turn under the ends, and machine zigzag it in place down the centre.

Floral addition
For a more feminine look, make your own bias binding with a tiny floral print (right). Cut the ends diagonally and zigzag stitch it in place with the machine.

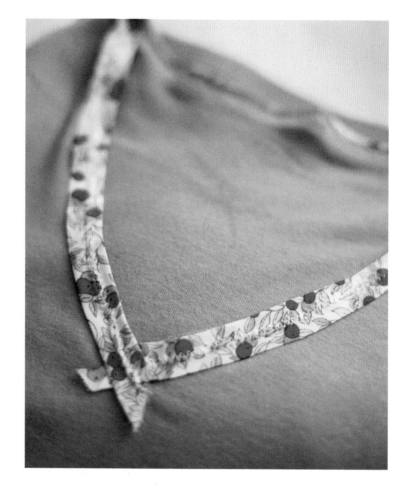

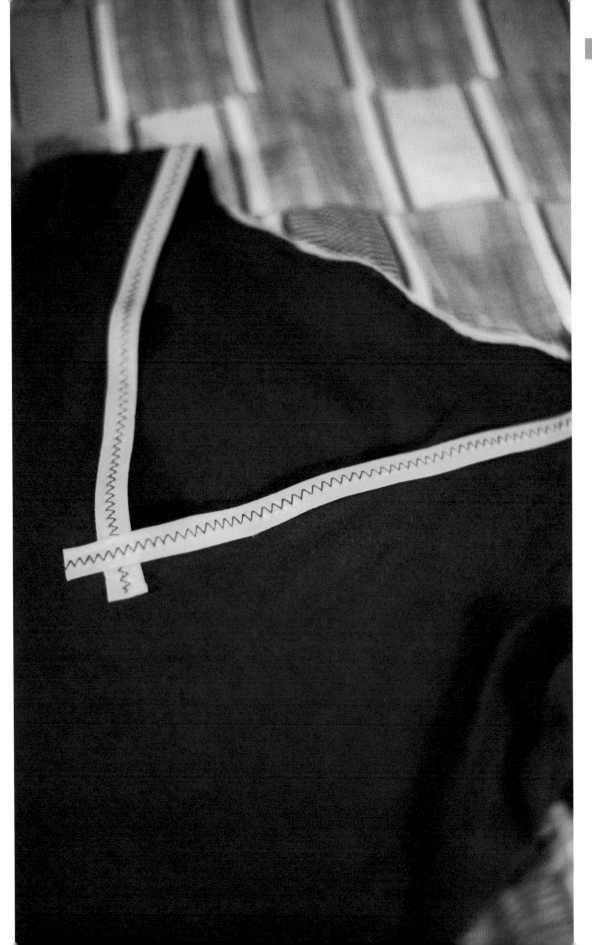

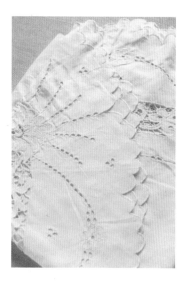

TABLECLOTH INTO SKIRT

The more you do in the way of transforming clothes, the more you start to look around for possibilities. I was rummaging through some household items at a car-boot sale and came across a lacy round tablecloth. I liked the lace, but not the colour, and I certainly didn't want a tablecloth, but it suddenly occurred to me that if I dyed it and cut a hole in the centre, it would make a great skirt.

So that's just what I did. I put the tablecloth in the washing machine with a scarlet machine dye, and it dyed just fine. Then I measured my own waist to figure out how big of a hole to cut at the centre. I folded the tablecloth into quarters, and cut a hole at the point and then a slit so I could slip it over my hips. To bind the waistline and slit, I used a wide ready-made bias binding. The results were perfect.

Obviously, the size of any tablecloth you find will determine whether you can make a suitable length skirt from it, but this one measured about 2m (2yd) in diameter.

If the hole you cut for the waistband turns out slightly larger than expected, don't despair – this is an easy mistake to make. Simply fold in the excess fabric to form subtle side pleats and add the waistband binding over them. Add hooks and eyes to fasten, or a button and button loop.

If you can't find a round tablecloth to suit, then you could always cut a circle from a dyed sheet and leave the edge raw.

Give it a twirl!
This old round lace tablecloth (above), dyed scarlet, made a great dance skirt with copious fabric (right) and a wonderfully lacy border at the hem (below). (See instructions on pages 118-119).

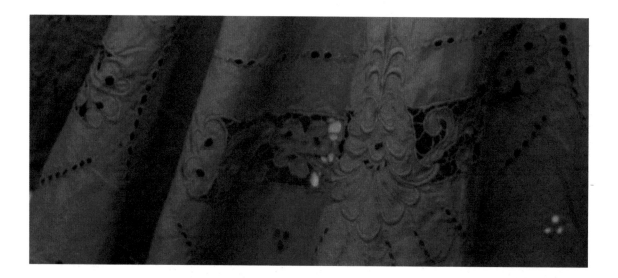

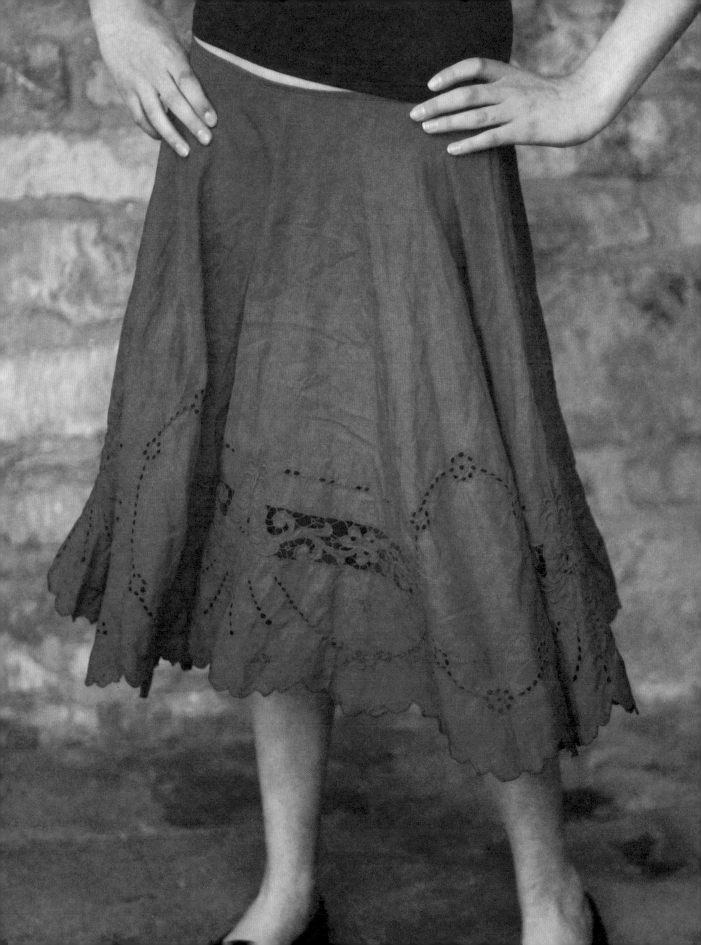

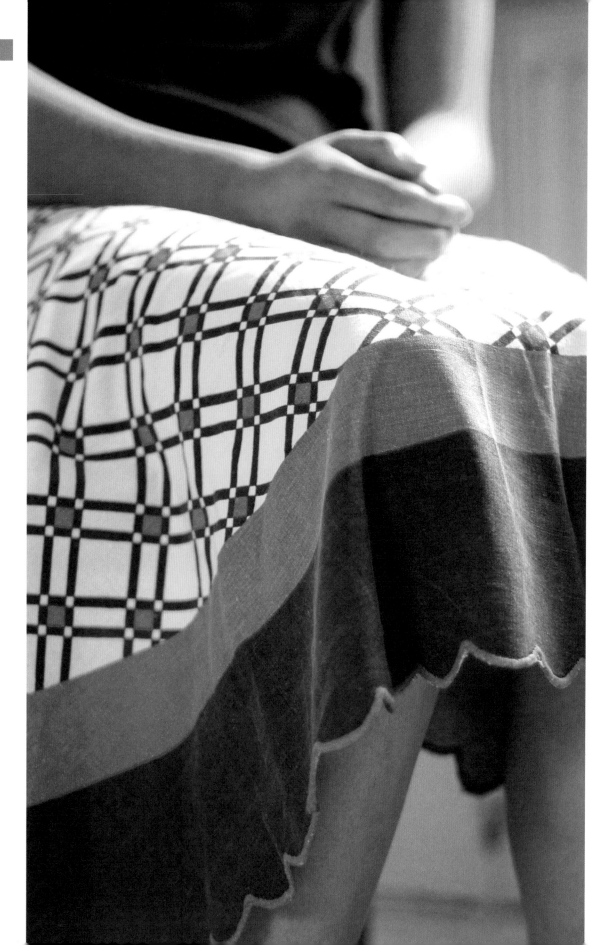

Having had some success with my dyed tablecloth, I then started to look around for other kinds of round tablecloth to do something similar with.

I found a striking one in navy and royal blue checks, with an interesting border detail that picked up the colours in the checks and that was finished with a neat scalloped edge. I made the skirt in exactly the same way as the red one (see pages 92-93), making sure that the length was right so that the border I liked so much ended up just where I wanted it.

If you find a tablecloth that isn't long enough, but love the pattern, why not layer it with a longer plain one? Both the circular skirts could then be sewn together at the waistband or made up separately so that they could be worn together or on their own.

You could pick up some of the ideas from the bordered skirt I made (see pages 84-85), or machine or hand embroider the border if you wished.

Check it out!

Here is another version of the skirt on pages 92-93, but this time the tablecloth came with its own contrasting border (left and below), which I simply used to my advantage. Embroiderers might like to embellish the border with stitching or ricrac.

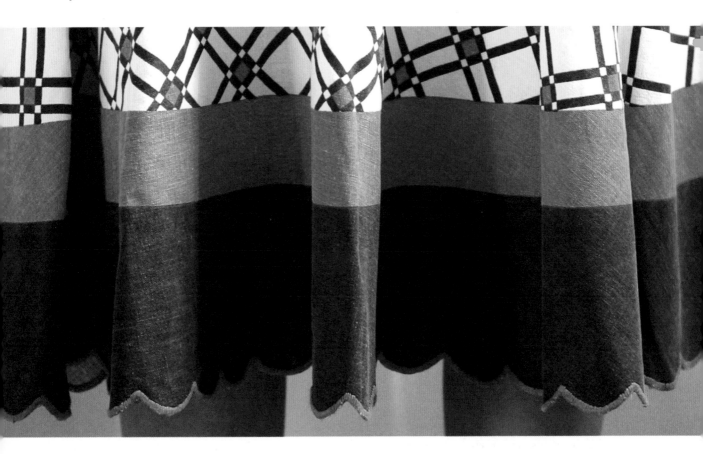

Finished but not gone!
These old pyjama trousers (above)
were so comfortable that I
couldn't bear to give them up.
Instead I cut out one of the legs
to make a sewing pattern for
a completely new pair (far right).
(See instructions on pages 110-111.)

Fancy finish at the waist
To turn the pyjamas into
something a bit more special, you
can line the waistband with a
black-and-white gingham (right)
and thread a bright scarlet
drawstring through it for a flash
of colour.

NEW PYJAMAS FROM OLD

If like me you wash and wear your pyjamas until they turn into rags,
you might well want to make your own from the pattern of a
particularly comfortable pair. This is easier to do than you might
think, fortunately, and would make a great combination with the
tired vests I dyed (see pages 18-19).

Pick a good quality lightweight cotton – I chose some rather mad
spots, but stripes always look good, too – as it washes well and just
gets more comfortable the more times you wash it.

Elastic threaded through the waistband is an easy way to finish
off the pyjamas, but a drawstring works fine, too.

If you like something more feminine, then cut the pyjamas to
capri-length and add some lace as on page 87.

For a nice detail, line the inside waistband with another fabric. A
simple black-and-white gingham would go well with my dotty
pyjamas, with a brightly coloured cord as the drawstring.

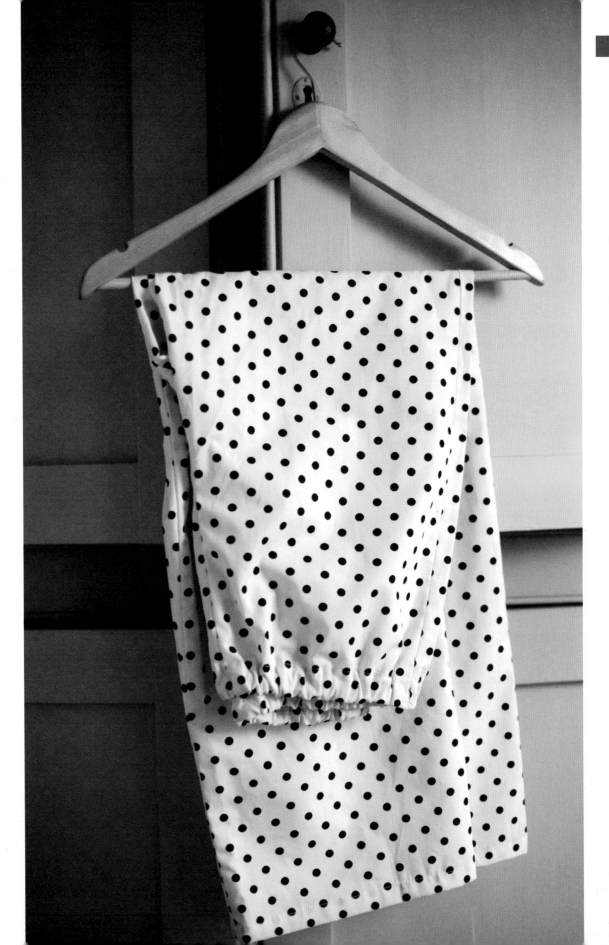

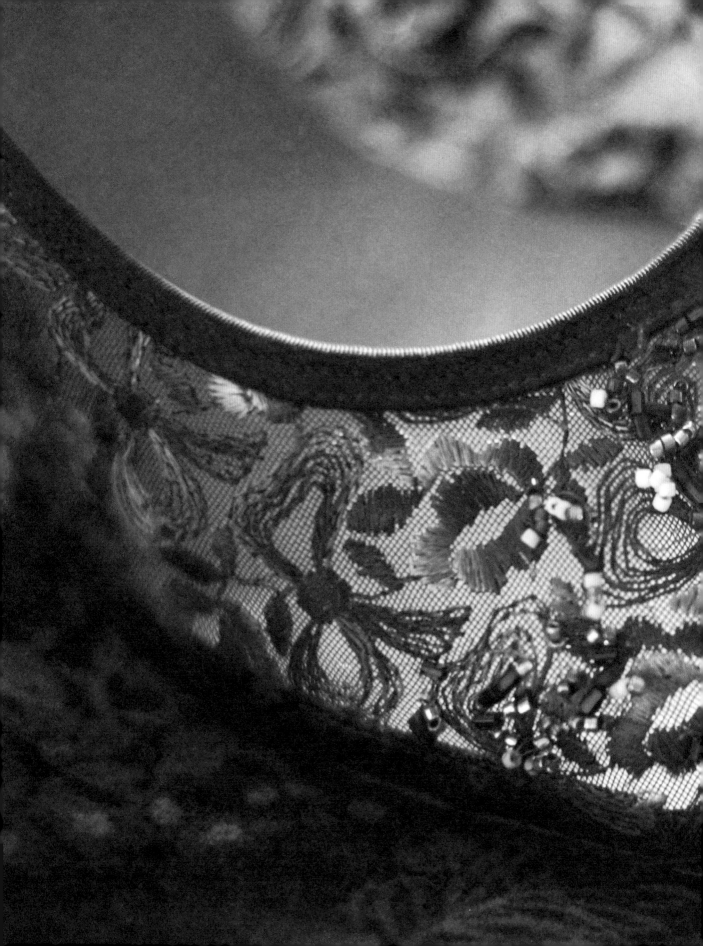

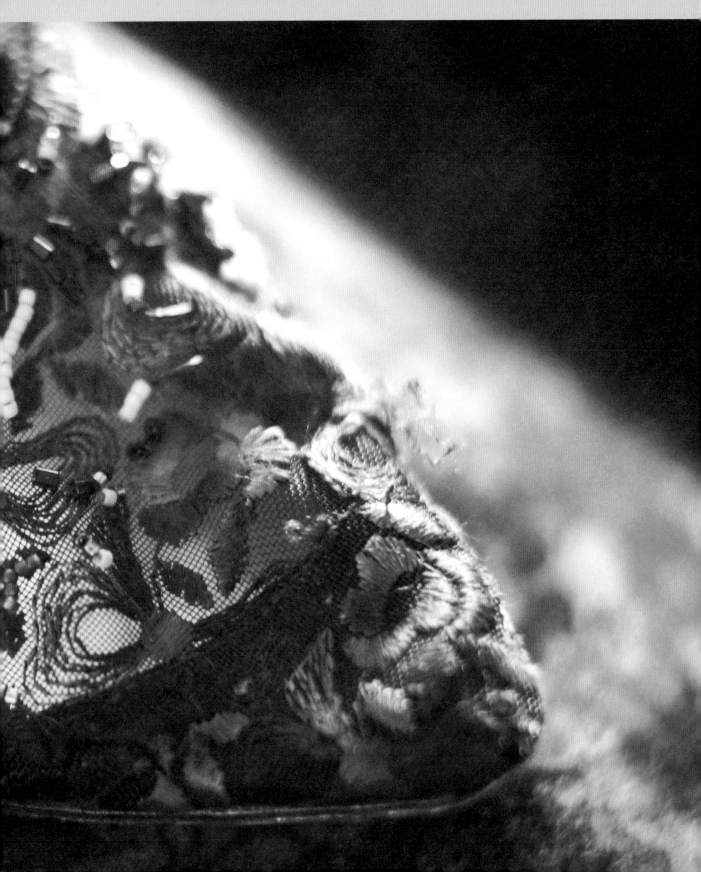

WHAT YOU NEED

Needle and thread

Rubber gloves

Wooden dowelling rod

Fabric dye

DIP-DYED SCARF

In dip-dyeing, you dip the fabric into the dye then pull it out (see page 30). You can use this method to dye the end of a long item, or to create a graded dyed effect, for example on the ends of a scarf (as shown here) or on a petticoat.

Make sure the fabric is clean, then moisten it thoroughly. Prepare the hand-dye bath according to the dye manufacturer's instructions, and put on a pair of rubber gloves. Follow the tips on page 28 for the dyeing process.

To dip-dye a scarf

1 Fold the scarf in half lengthways and mark the halfway fold with tacking stitches. Hang the scarf over a dowelling rod at this mark.

2 Dip the ends of the scarf in the dye bath and leave for the length of time needed to achieve a light dye shade.

3 Gradually, pull the scarf upwards in stages so that the ends stay in the dye bath the longest. This will create a graded effect.

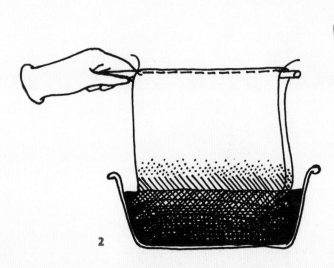

1

2

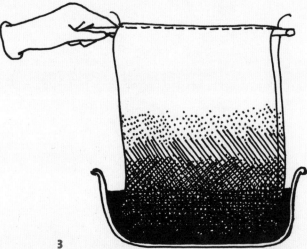

3

TIE-DYED SKIRT AND TOP

You can use the tie-dye technique to create interesting broken lines of undyed colour on garments or household items. To tie-dye, you gather the fabric where you want an undyed line, then secure it with rubber bands before dipping the whole item into the dye bath in the usual way (see pages 126-127).

The instructions below are for the skirt on page 33. For the top on page 32, follow the same procedure to tie-dye lines across the straps.

To tie-dye a skirt

1 Mark the position for the undyed border first. Measure up from the hem of the skirt with a tape measure, and mark a line with a water-soluble pen.

2 Stitch over this line with running stitches and pull the thread to gather the fabric together.

3 Finally, secure the gathered line tightly with a few elastic bands and hand-dye the skirt in the usual way. When the fabric is dry, remove the rubber bands and gathering stitches.

WHAT YOU NEED

Tape measure

Water-soluble pen

Needle and thread

Elastic bands

Fabric dye

1

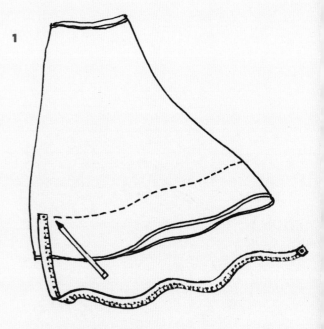

2

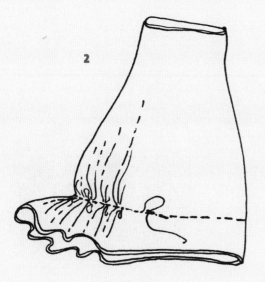

3

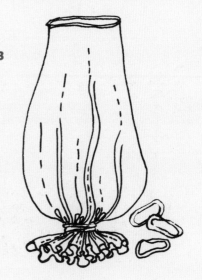

WHAT YOU NEED

Tape measure

Flexible cardboard

White spirit

Pen

Scalpel

Paper clips

Adhesive tape

Shoe dye and sponge applicator

STENCILLED SHOES

Using standard shoe dyes, you can jazz up a pair of plain shoes or sandals by adding a stencilled pattern, such as these polka dots (see page 35).

To stencil the dots

1 To make a stencil, first measure the area to be stencilled. Then cut a piece of flexible cardboard to this size, adding extra at the ends to tape to the sole of the shoe. Draw a few small circles on the cardboard stencil and cut them out with a scalpel.

2 Clean the shoes and remove any polish with white spirit. Then using paper clips, attach the stencil to the shoe and tape the ends to the sole.

3 Sponge the chosen dye colour through the stencil. Leave the shoes to dry before removing the stencil.

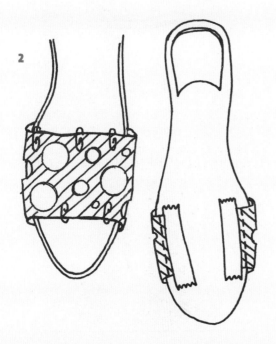

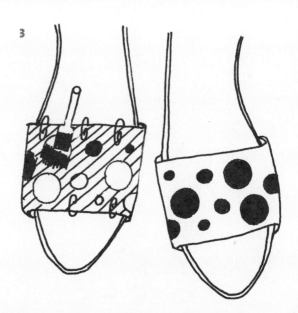

BEADED SHOES

If you have a pair of patterned fabric-covered shoes, or a patterned handbag or collar, you can partially bead the pattern to add a bit of glitter (see pages 56-57).

When beading you can speed up the process by stitching on several small beads at a time using a technique called lane beading (see page 139). Larger beads can be applied singly. For rich effect, buy a mixture of round beads and cylindrical ones, known as bugle beads.

To bead the shoes

1 To work outlines or cover large areas, stitch on small beads using lane beading and a strong matching buttonhole thread.

2 Stitch on larger beads one at a time.

WHAT YOU NEED

Needle and strong matching thread
Mixed beads – round and cylindrical

Tape measure

Water-soluble pen

Mixed snap-on crystals

BEADED NECKLINES

If you want to create a regularly spaced beaded design around the neckline on a garment, such as on a camisole (see page 54) or a V-neck top, start by carefully planning the beading pattern. If you prefer, use French knots (see page 138) in a contrasting colour to create an effect similar to that of beading.

To bead a camisole neckline

1 Using a tape measure and a water-soluble pen, mark the positions of the rows of beads along the neckline and armholes.

2 To attach each snap-on crystal, push the little metal teeth of the bead base through the fabric from the wrong side, then snap the crystal onto it.

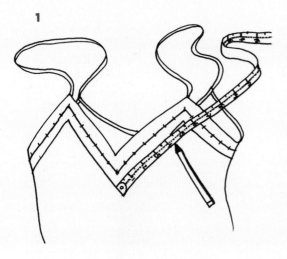

To bead a V-neck top

Follow the instructions above to mark the positions for the two rows of beads around the neckline (see below), and carefully snap on the crystals one at a time.

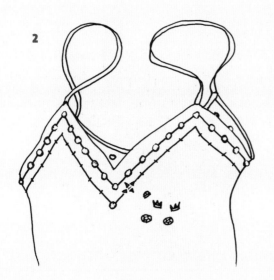

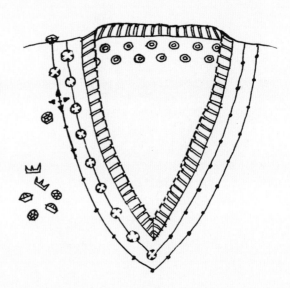

BEADED POLO COLLAR

To copy the beaded poloneck sweater on page 58, follow the instructions below. Because knitting unravels when cut, you must make sure you secure the cut edges with stitching before starting the beading.

To bead a polo collar

1 Cut down the shoulder seam line on the collar with a sharp pair of scissors.

2 To secure the cut edges, stitch them using the zigzag stitch on the sewing machine.

3 Using a matching thread, stitch the selected beads to both cut edges of the collar in whatever pattern you like.

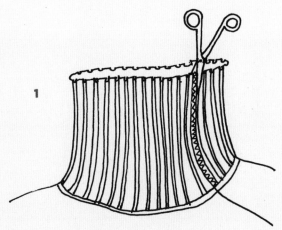

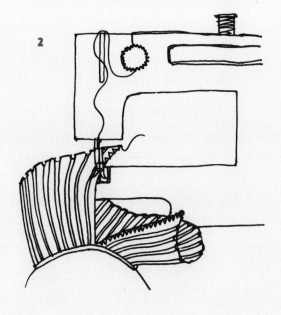

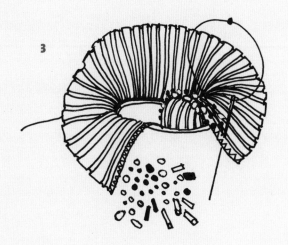

WHAT YOU NEED

Tape measure

Wide satin ribbon

Pins

Needle and matching thread

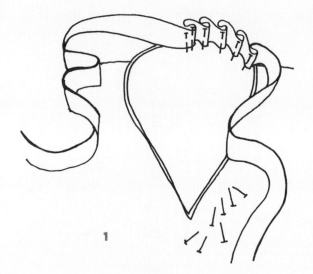

1

RIBBON-EDGED NECKLINE

If you want to add a wide satin ribbon to a sweater neckline, you must pleat it to fit it around the curved edge (see pages 40 and 41).

To attach a ribbon

1 Cut a length of wide satin ribbon at least two and half times as long as the neckline, plus 75cm (30in) extra for the bow. Pin the ribbon to the right side of the neckline in tiny pleats, starting at the centre back and working first one side then the other. Make sure the pleats are evenly spaced.

2 Stitch the pleated ribbon in place with small backstitches (see page 137).

3 Tie the remaining ribbon in a bow (see page 42), and trim off the ends diagonally.

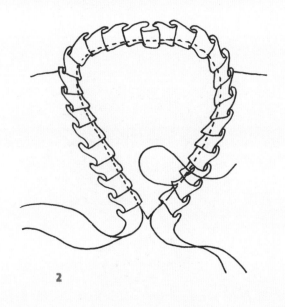

2

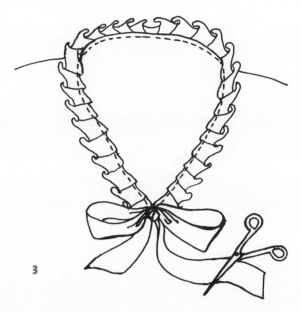

3

RUFFLE-EDGED NECKLINE

For this neck edging (see page 43), you machine stitch free-motion embroidery over water-soluble vanishing fabric (see page 129 for instructions). The water-soluble fabric is removed by soaking the garment in water after the stitching is completed.

To machine-stitch the edging

1 If you have cut a new V-shaped neckline, tack around it close to the edge to keep it firm.

2 Pin strips of water-soluble fabric around the neck and tack them in place.

3 Stitch circles back and forth over the edge of the neckline to create a border 6mm (¼in) wide. Make sure the stitches overlap each other and cover the neck edge. Rinse out the water-soluble fabric.

WHAT YOU NEED

Needle and matching thread

Water-soluble vanishing fabric

Pins

Sewing machine

Matching or contrasting thread

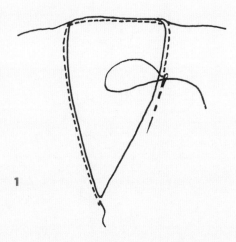

1

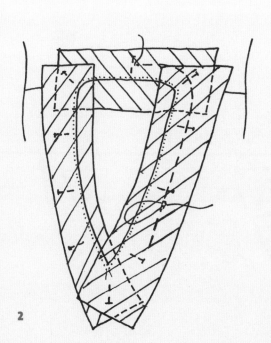

2

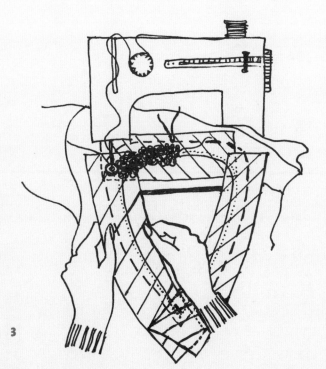

3

WHAT YOU NEED

Fabric flower with several layers of petals

Snap-on crystals

Pins

Needle and matching thread

Sewing machine

APPLIQUÉ CARDIGAN

To add appliqué flowers to a cardigan (see page 61), you must first prepare the appliqué by dismantling a fabric flower and discarding the stem. Stitch the appliqué in place with free-motion embroidery (see page 129 for instructions).

To appliqué a cardigan

1 Take apart a multi-layered fabric flower.

2 Mark the positions for the appliqué flowers on the cardigan. Then pin and tack them in place.

3 Free-motion machine stitch the appliqué in place, stitching around each flower edge in a continuous line and at the centre of the flower in the same way as shown. Snap on a crystal at the centre of each flower (see page 104), then add beads in random positions around the flowers.

1

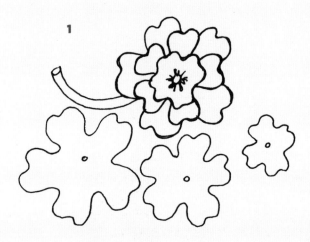

2

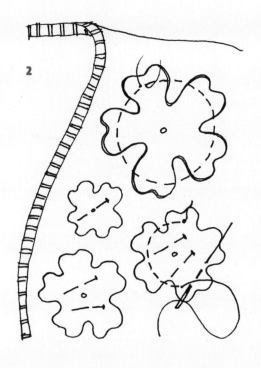

3

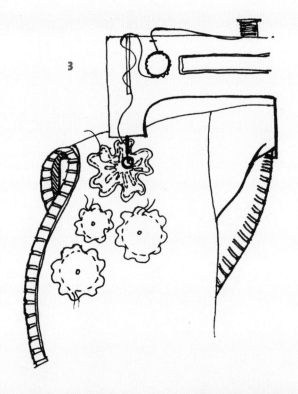

A HALTER TOP FROM A SCARF

You can make a simple halter top from a large scarf in no time at all (see pages 72–75). Just make sure you have the necessary materials (see right) and follow the instructions below.

To make a halter top

1 Fold the scarf in half diagonally, from corner to corner, with the wrong sides together.

2 Fold over the 90-degree corner 10cm (4in) from the point, and hand (or machine) stitch about 2.5cm (1in) from the fold to form a channel.

3 Pin a safety pin to one end of a length of fabric tape or narrow ribbon and thread it through the stitched channel. Remove the safety pin. Tie the tape or ribbon around the neck and the two scarf points around the waist.

WHAT YOU NEED

Scarf, 1m (39in) square

Needle and matching thread

Matching fabric tape or narrow ribbon

Safety pin

Sewing machine (optional)

WHAT YOU NEED

Old felted sweater

Pins

Water-soluble pen

Sewing thread

Contrasting wool yarn

Blunt-ended yarn needle

A BOLERO FROM A SWEATER

You can make a neat bolero from a sweater that has been inadvertently shrunk and felted in the washing machine (see pages 68-69). The bolero shown here is embroidered with large running stitches, but you can use whatever embroidery stitch you fancy.

To make a bolero

1 Cut off the ribbed cuffs on the sweater to create three-quarter-length sleeves. Then fold the front of the sweater in half, with the wrong sides together and the shoulder and side seams aligned, and pin as shown. Cut along the fold at the centre front.

2 Carefully repin the right and left fronts together along the proposed front edges. With a water-soluble pen, mark the shape of the bolero on the right side of one front, using a plate or bowl to trace an even curve at the bottom of the front.

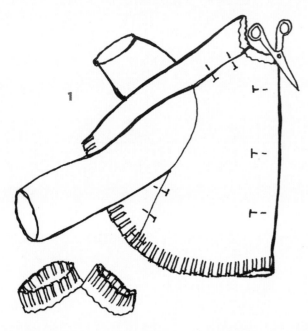

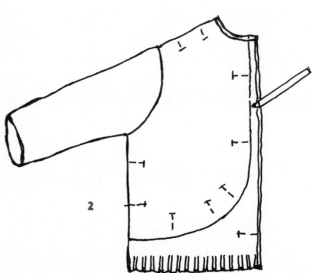

3 Mark the bottom edge of the bolero on the back as well. Then cut along the marked line through both layers of the sweater at the same time.

4 Using sewing thread and a needle, work short tacking stitches along the edges of the neckline, fronts, back, and cuffs to keep them flat and firm for embroidering.

5 Using wool yarn and a blunt-ended yarn needle, embroider 6mm (¼in) long running stitches around the neckline, fronts, back, and cuffs, about 2.5cm (1in) from the edge. Remove the tacking stitches, and press with a warm iron over a damp cloth.

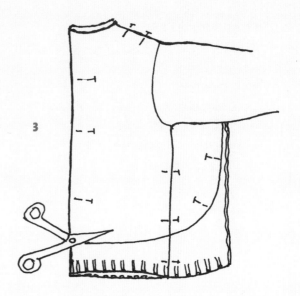

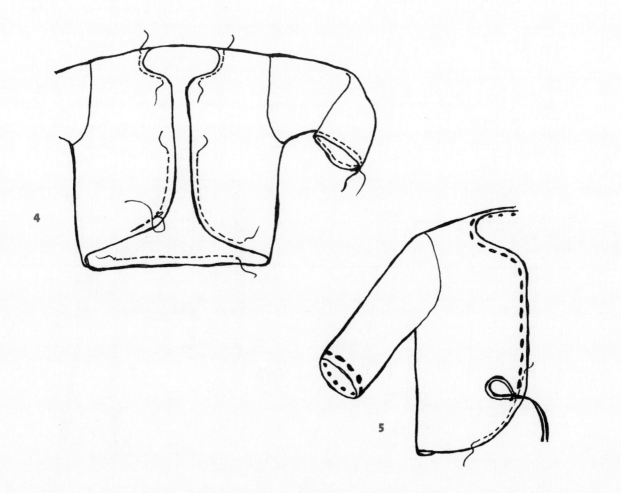

WHAT YOU NEED

Old leather skirt

Tape measure

Tailor's chalk pencil

Strong, permanent double-sided adhesive tape

Sewing machine

Special leather sewing-machine needle

Matching button thread

A BAG FROM A LEATHER SKIRT

I made the bags shown on pages 70-71 from a classic straight leather skirt. The stitching on the type of skirt I used makes perfect decoration for the bag, but this element is not essential.

You will need a special leather needle on your sewing machine to sew leather and a strong thread, such as button thread.

To make a bag

1 Calculate the size of the rectangle for the bag (or make a rectangular template to the size required), adding 6mm (¼in) extra at the sides and base for seam allowances and 5cm (2in) at the top for the top hem. Mark the rectangle on the skirt with a tailor's chalk pencil (**A**). Mark long strips for the handles (**B**) to twice the required handle width.

2 Cut out the bag front and back, and the two handles. Stick strong permanent double-sided adhesive tape to the wrong side of the long edges of each handle, fold each edge to the centre, and stick down in the centre as shown.

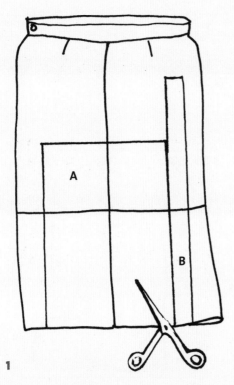

1

2

3 Turn 5cm (2in) to the wrong side along the top of the bag front, and mark the positions for the handles on the right side. Repeat on the bag back. Using matching button thread, machine stitch the handles in place, stitching in a square, then across the square diagonally in each direction to strengthen.

3

4 Place the bag back on top of the bag front, with the right sides together. Stitch the bag front and back together around the sides and base, leaving a 6mm (¼in) seam allowance. Finally, clip off the corners of the seam allowances close to the stitching as shown, to remove bulk. Turn the bag right-side out.

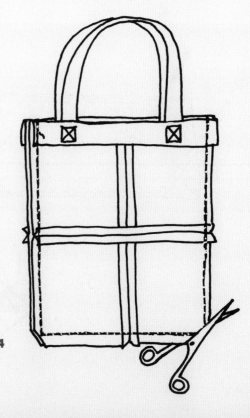

4

WHAT YOU NEED

Old garment

Tape measure

Water-soluble pen

Pins

Interfacing

Narrow ribbon for ties

Matching thread

Sewing machine

A BELT FROM A SKIRT

You can make a simple fabric belt, either from an old skirt or other garment (see pages 80-81). You will need enough fabric to go around your waist. The belt shown here is 15cm (6in) wide, but you can adapt the width to suit your own needs. You need enough fabric for double the final width, but you can use a different fabric for the backing if necessary.

To make the belt

1 Cut out two identical strips of fabric to the required finished belt measurements, plus extra all around for 1.5cm (½in) seam allowances. Pin the two strips to each other with right sides together. Using a water-soluble pen, mark a neat V-shape at each end on the wrong side of one strip, then mark the seam line. Cut the pointed ends. Then cut a piece of interfacing to the same size.

2 Unpin the two fabric strips and tack a length of ribbon to the seam allowance at each end of the right side of one strip. Pin the ribbon to the centre so that only the ends will be caught in the seams.

1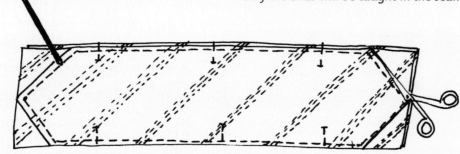

2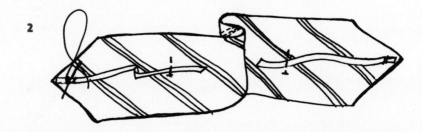

3 Place the belt strips on top of each other again with the right sides together, then place the interfacing on top. Pin and tack. Using a matching thread, machine stitch around the belt as shown, leaving a 10cm (4in) gap in the stitching at one side of the belt so that you can turn it right-side out.

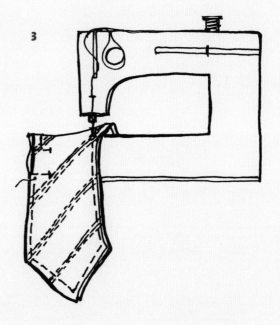

4 Remove the tacking and turn the belt right-side out. Carefully turn the seam allowances inside along the opening and press. Hand stitch the opening closed. Then machine topstitch neatly around the belt, close to the edge, to finish.

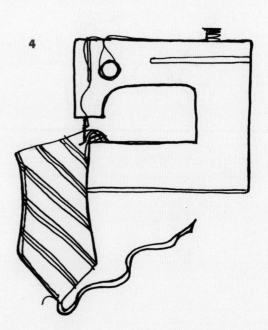

WHAT YOU NEED

Old shirt

Friend to help

Pins

Needle and matching thread

Sewing machine

A PIN-TUCKED BLOUSE FROM A SHIRT

To make an old classic shirt into a fitted blouse, you can take tucks in the shoulders and the waist-to-bust area of the shirt (see pages 88 and 89). You will need a friend to help you, as the easiest way to pin the tucks is to do so while wearing the garment. You can also turn long sleeves into three-quarter-length ones, making tucks as explained below along the sleeve ends, then hemming them.

To make a pin-tucked blouse

1 Working on the right side of the shirt and on one side only, pin the 6mm (¼in) tucks along one shoulder as shown. Take as many tucks as you need to reduce the shoulder width to the required size.

2 Then pin and tack the same number of matching tucks from the waist to the bust, following the lines of the shoulder tucks. (You can draw matching lines with

1

2

a water-soluble pen from the shoulder tucks or make
the tucks by eye).

3 Fold the shirt in half and pin, matching the tucks
on the back shoulder section (on the same side)
and on the back waist-to-bust area on the same side
in the same way. Tack the pinned tucks in position.
Then pin and tack matching tucks on the other side of
the shirt.

4 Using matching thread, machine topstitch all the
tucks in place on the right side of the shirt, close to
each fold line. Topstitch the shoulder tucks on the back
and front on each side first, then stitch the waist-to-
bust tucks on both the back and front of the shirt.
Remove the tacking stitches and press.

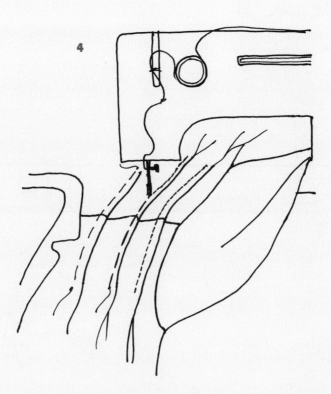

Old round tablecloth

Tape measure

Water-soluble pen

Pins

Wide bias binding

Needle and matching thread

Sewing machine

Button

A SKIRT FROM A ROUND TABLECLOTH

You can make a round tablecloth into a skirt by simply cutting an opening in the centre and stitching on a waistband (see pages 92-93). If the tablecloth is not the desired length, you will have to make a new hem (see pages 132-133). The waistband and side slit can be faced with bias binding.

To make a skirt

1 Fold the tablecloth in half and then in half again. Tracing around a plate with a water-soluble pen, draw a circle at the centre that is 5cm (2in) longer than your waist (so the waistband will overlap).

2 Open out the tablecloth and draw the full circle. Then draw a seam allowance 1.5cm (½in) from the marked waistline and a slit about 15cm (6in) long from the marked waistline. Cut out the centre circle of fabric and cut the slit. (Try on the skirt to make sure it fits over your hips and adjust if necessary.)

3 Machine stitch around the waist opening and the side opening, about 6mm (¼in) from the raw edge.

1

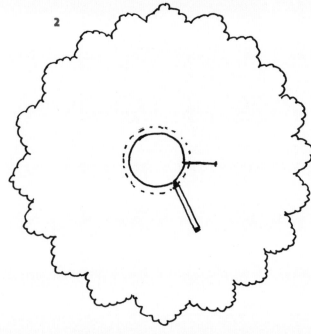

2

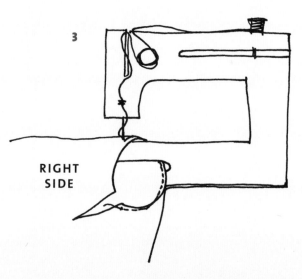

3

RIGHT
SIDE

4 To bind the slit, pin and tack bias binding along the edges with the right sides together as shown. Machine stitch in place and remove the tacking. Then press the binding to the wrong side and hand stitch in place.

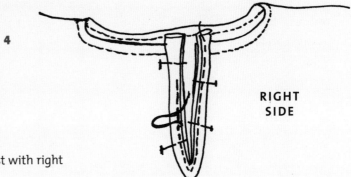

4

RIGHT
SIDE

5 Pin and tack bias binding along the waist with right sides together as shown.

6 Remove the tacking and press the bias binding to the wrong side. With the wrong side up, machine stitch the waistband in place. Make a button loop (see page 136) and sew on the button (see page 134).

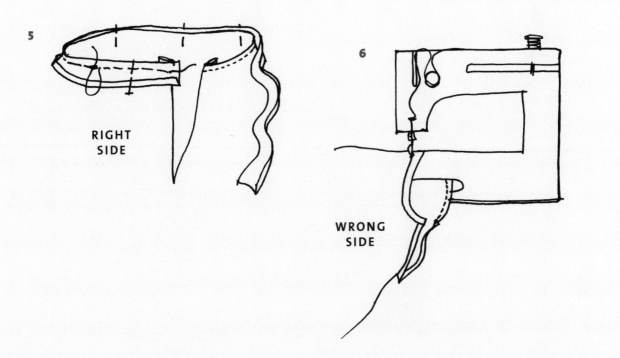

5

RIGHT
SIDE

6

WRONG
SIDE

WHAT YOU NEED

Old pair of drawstring pyjama trousers

Tape measure

Pins

Tailor's chalk pencil

Matching thread

Sewing machine

Ribbon or cord for drawstring

Safety pin

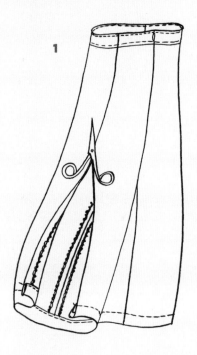

NEW TROUSERS FROM OLD

I made a new pair of drawstring trousers using pattern pieces cut from a comfortable old pair of pyjamas (see pages 96-97). You simply cut out the front and back of one trouser leg (there is no need to unpick seams) and use these fabric pieces as pattern pieces. You can adapt this idea, using any fairly simple garment that is an old, worn-out favourite.

To make capri pants, full-length trousers, or shorts, just alter the leg length.

If your fabric is 1m (39in) wide, you will need to buy a length of fabric that is twice the length of your proposed new trousers.

To make drawstring trousers

1 Take an old pair of trousers and cut down the side seams, then down the back and front seams.

2 You now have the basic pattern pieces for the back leg piece and the front leg piece (the legs are identical). Write labels on the pattern pieces. Fold the fabric in half with right sides together so there are two layers, then lay the pattern pieces on top on the straight grain. Using tailor's chalk, draw around the patterns, adding 1.5cm (½in) all around for seam allowances. Add an extra 10cm (4in) at the top for the waistband. If desired, adapt the length now. Cut out the pieces.

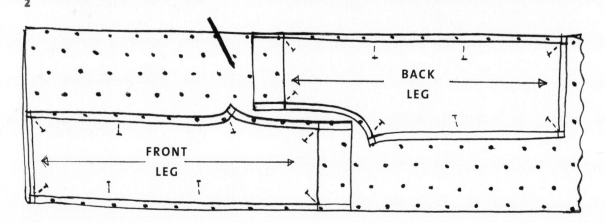

3 With right sides together, pin, tack, and machine stitch the waist-to-crotch seams on the trouser back and front, then the inside leg seams, and lastly the side seams. Remove the tacking and press the seams open after stitching each seam. (If you want to make very durable trousers, you can make French seams instead as explained on page 130.)

4 Turn under a hem at the top of the trousers to form a waistband. Pin, tack, and machine stitch in place (see pages 132-133). Remove the tacking and press.

5 Open up the front waistband seam so you can insert a drawstring. Secure the top and bottom of the opening with a few hand stitches. Pin a safety pin to one end of the drawstring, push it through the opening, and pull it along the inside of the waistband channel until it emerges through the opening again. Remove the safety pin. Hem the trouser legs and press.

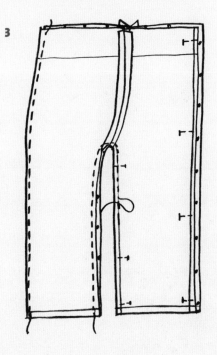

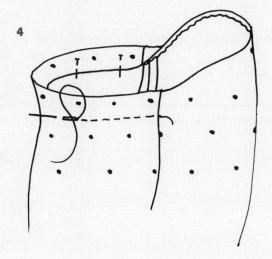

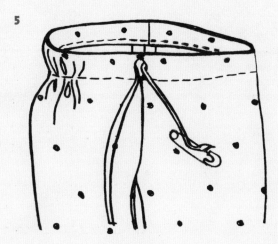

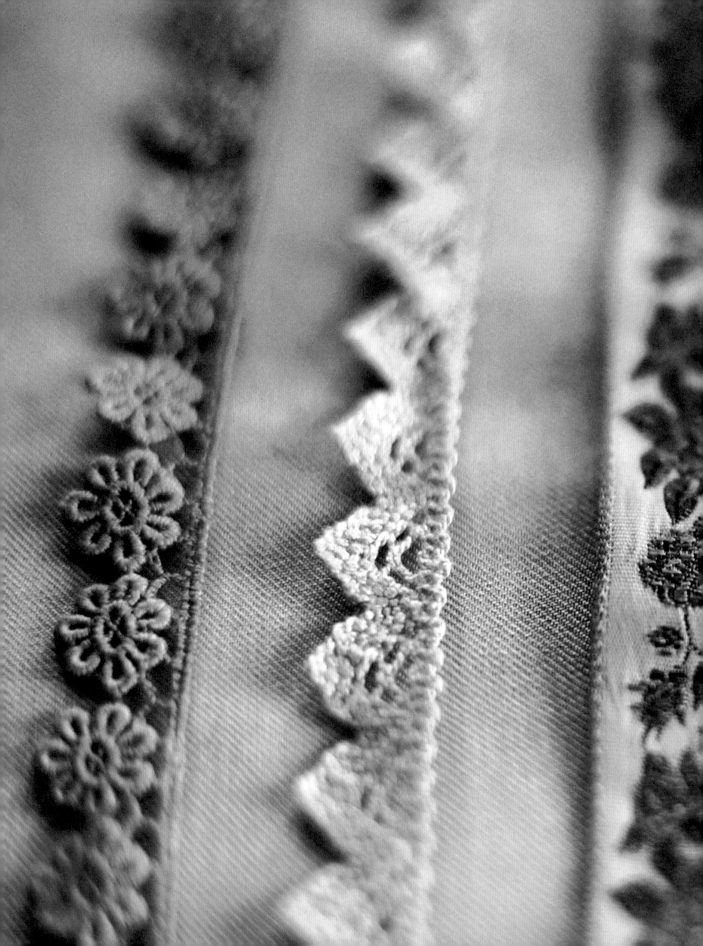

KNOWING WHAT TO DO

If you are interested in revamping your wardrobe and finding new uses for old items of clothing or accessories, then you will have to learn a few practical needlecraft skills. Not so very long ago, all girls were taught the basics of needlecraft in primary school (while the boys did woodwork or metalwork), but a whole generation has grown up without even the most basic skills, such as sewing on buttons!

This section is not a complete guide to everything any girl (or boy!) needs to know, but it will, I hope, help you to make the projects I have shown in the book, or something very similar to them, and also give you a few clues as to how to go about some basic hand and machine stitching, and basic dyeing.

I have deliberately limited the alterations in this book to the kinds of things that a non-professional can do relatively easily, but beware, because there are many other ideas that appear to be easy to the uninitiated but are not. While it is no big deal if you mess up a charity shop bargain in the process, it is a waste of time, which can be irritating, to say the least.

Altering clothes

Some fabrics are much easier to cut and sew than others. Cottons, linens, and plain wools are relatively easy to work with. Silky fabrics are harder to handle because they tend to fray easily and slip as you stitch them. Leather is not difficult to work with but you need to use a special needle and strong thread with it (see page 70).

Easy alteration ideas
SHORTENING TROUSERS OR SKIRTS

A straight or an A-line skirt just needs to be turned up and hemmed (see pages 132-133), but shortening a circular skirt is harder as the material has to be eased into the hem. Shortening a pair of trousers (other than

jeans, which have double seams) or a simple top
without an opening is also easy.

LENGTHENING TROUSERS OR SKIRTS

Lengthening trousers and skirts is no trouble at all.
Simply let down an existing hem (add a piece of tape if
it is too short) and rehem, or add a border (see page 84).

CHANGING THE BUTTONS

Changing buttons makes a big difference (opposite),
but make sure you measure the buttonhole first and
do not buy buttons that are too small as they will slip
through the holes.

MAKING A NEW BUTTONHOLE(S)

If you have a sewing machine with a buttonhole foot
and know how to use it, it is easy to make buttonholes.

TAKING IN GARMENTS THAT ARE TOO LARGE

You can take in a top at the sides if it doesn't have set-
in sleeves, but fitted skirts are difficult to alter. If a skirt
waistband is too big, add loops (see page 136) and
cinch it with a belt or a scarf pulled through an old
buckle or brooch (right).

COVERING STAINS, MOTH-HOLES, OR TEARS

Cover imperfections with appliqué flowers, braids,
beads, trims, or bows.

PUTTING IN A NEW ZIPPER

Putting in a new zipper requires some sewing
knowledge. If you want to try it, get a good sewing
guide and carefully follow the instructions.

RECUTTING A NECKLINE

You can, of course, change a round neck to a square-
or V-neck using the methods I have shown on pages
90-91. Facing a neckline requires dressmaking skills.

GENERAL RULES FOR DYEING

1 Always make sure the fabric to be dyed is clean and thoroughly damp before you start. It must also be stain-free as stains will probably show even after dyeing.

2 If you want to achieve the depth of colour on the packet, make sure you weigh the item and follow the manufacturer's guidelines as to the quantity of dye for the weight of the garment.

3 Use the appropriate quantity of common salt indicated in the dyeing instructions. The salt disperses the dye and prevents it from blotching.

4 Always rinse the dyed fabric well, and wash it separately at least once before washing it in the machine with a load of other items. ALWAYS wash coloureds separately from whites, unless you want delicately tinted underpants or pillow cases.

(See page 28 for more dyeing tips.)

DYEING BASICS

Dyeing textiles is one of the oldest arts, and is still practised in parts of Africa today using hand-picked plants and big dye pots. These dyed African fabrics are often spectacular and worth researching if the subject fascinates you.

If you fancy some homespun dyeing, you can use a number of kitchen-sink items for pretty good results. For example, tea and coffee make great dyes for overly bright white linen, turning it into instantly antique-looking fabric. This is particularly useful for turning a modern white lace edging into something suitable for, say, an old silk dress.

Natural dyes

There are quite a few natural dyes. These come mainly from plants, but some from minerals. Of the plant-based dyes, there are a few that you can use at home that require no harsh chemical fixatives, but the simplest dye to use is tea or coffee.

Tea- or coffee-dyeing

Make a really strong pot of coffee or tea (about 4-5 tablespoons coffee/tea to one pint of water). Dampen the article to be dyed. Pour the tea or coffee into a basin, top up to two quarts with very hot water, and add a cup of salt. Steep the fabric in this dye bath for half an hour. Rinse twice and hang out to dry.

Basic chemical dyes

Reputable chemical dyes are available in small packets or pots (see Suppliers on page 140). They are purpose-made for different fabrics, either for hand or machine dyeing, and as cold-water or hot-water dyes. In general, the depth of colour achieved depends on two factors: firstly, the quantity of dyestuff used for the weight of the garment and, secondly, the composition of the fabric. Natural fabrics (cottons, linen, silk, wool)

take dye well and produce the deepest shades. Synthetic fabrics take it less well and will dye to a much lighter shade. Obviously, if a garment is made of mixed fabric types, you will get a variable result.

Be aware that not all natural fabrics are stitched with natural threads, so any synthetic seam or topstitching threads will probably dye to a much lighter shade. This might create an interesting effect (see the vests on pages 18-19), or one that ruins the garment. You have no real way of telling beforehand, unless you want to unpick some of the stitching and run a test. Somehow, I doubt if any of us have the time to do this. It's better to have a go and chuck it out if it looks horrid!

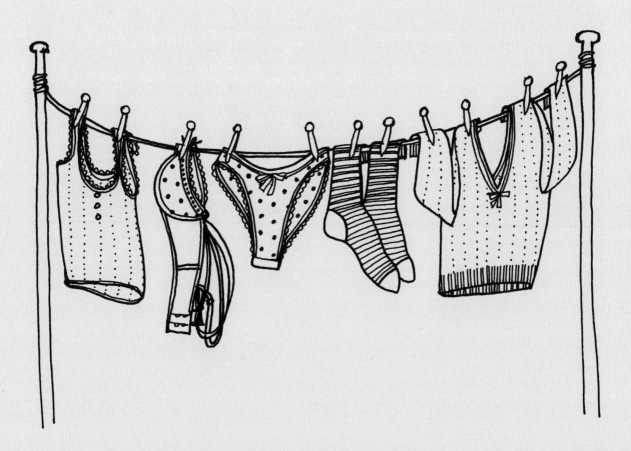

STARTING TO STITCH

It is unlikely that you have bought this book if you do not own a sewing machine. In theory, you could do most of the sewing by hand, but it would take you a very long time!

Some stitching does have to be done by hand, like it or not – for example, sewing on buttons, adding hooks and eyes (see pages 134–136), and hand embroidering (see the hand-decorated buttons on pages 48-49 and the bolero on pages 68-9).

It is well worth your while setting yourself up with a small sewing kit. Keep it in a pretty sewing box (it may tempt you to do more!) and ensure that you have the items shown below (see list left). Always work in good conditions: have a good anglepoise light, or

SEWING KIT

Packet of general sewing needles

Packet of crewel embroidery needles

Cotton sewing thread in black and white (Buy more colours as required, remembering to use thread a shade DARKER than the fabric so it shows up less.)

Dressmaking shears (Buy good ones and ONLY use them for fabric. If you use them for paper, even once, you will blunt them.)

Embroidery scissors

Pinking shears (These are not essential but are useful for making zigzagged edges that prevent fabric from fraying.)

Tape measure

Thimble (This helps to push the needle through thick fabric and to prevent holes in the fingertips.)

Dressmaker's steel pins

Packet of hooks and eyes, and poppers

Safety pins (These are useful for threading elastic and drawstrings through waistbands.)

similar, and an ironing board and iron set up close by. If you have a machine, make sure it is on a table, in good light, and at a comfortable height to work with.

Sewing machines

I do all my sewing on a fairly ancient Singer sewing machine, which does only straight stitch, so you don't need anything fancy. Modern machines, however, will do pretty much anything you want them to. One benefit they offer is that they all have a zigzag-stitch facility, which is great for preventing seam edges from fraying. Another is that many will also do a range of embroidery stitches, at the flick of a switch.

Some come with lots of attachments that look like something out of a medieval torturer's travel kit, but once you get the hang of buttonhole or zipper attachments they will make short work of many different kinds of dressmaking or alteration, although such things are beyond the scope of this small book.

Sewing machines will do the work for you, but it helps to understand how they operate. Basically, the needle drives the thread in and out of the fabric, catching a second thread held in a bobbin beneath the throat plate, so that the two threads loop together.

The tightness of the stitches is known as the tension, and you can adjust this according to the thickness of the fabric or the thickness of the thread. People like me, who make a living out of fashion embroidery, enjoy playing with the tension to create interesting stitching effects. People like you often find that you get untidy effects with the tension when what you want is a nice, regular, simple stitch. So be sure to TEST the fabric and the stitch length before you start a sewing project. It will save time in the end. You don't want to discover that you have sewn an entire skirt in wobbly stitches that are so loose they just fall apart!

FREE-MOTION EMBROIDERY

If you want to make the neckline edging shown on page 43 or attach appliqué like that on page 61, you will need to do so with free-motion machine embroidery on your sewing machine. To do this, you need a special presser foot, known as a darning foot. You also need to set the machine up so that the fabric is not gripped by the feed dogs (the sharp teeth under the throat plate). You drop down the presser foot lever in the usual way, but you disengage the feed dogs so you can move the fabric around to control the stitch path. Practise first on some spare fabric to see how to work the technique.

SEAMS

Most machine stitching involves sewing two pieces of fabric together to form seams. These need to be durable and hard-wearing, as they take a lot of strain in garments. The hand stitch commonly used for seams is backstitch (see page 137), which makes a dense stitch. On a sewing machine, a stitch similar in appearance is used. Whether you are hand or machine seaming, you always start by placing the two fabric pieces on top of each other with the right sides together and the raw edges aligned. You then pin and tack along the seam line.

For a standard straight seam, the seam is stitched about 1.5cm (½in) from the edge of the fabric; this ensures that the raw edges do not unravel to the point where the seam splits open. To prevent fraying, the raw edges can be finished by either zigzag stitching, tiny hems, or pinking (see opposite).

Flat seams

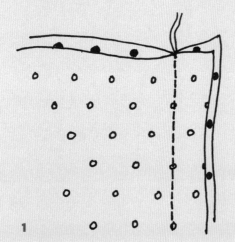

1 Align the raw edges of the two pieces of fabric, with the right sides together. Then pin, with the pins at right angles to the seam line so you remove them easily while stitching. Machine stitch about 1.5cm (½in) from the edge.

2 On the wrong side of the work, press the seam open.

French seams

If you are working with very fine fabric, or fabric that frays very easily, you can make a strong double seam, known as a French seam.

To make a French seam, stitch the first seam in the usual way and 6mm (¼in) from the edge, but with the fabric wrong sides together. Trim the seam allowances slightly. Then fold along the seam line with right sides together and press. Stitch a second seam 6mm (¼in) from the folded edge to enclose the raw edges.

To neaten seam edges

There are various methods of neatening seam allowances. Choose one of the following according to the type of sewing machine you have and the durability needed for the project. Pinked edges are not ideal for items that are frequently washed, for example.

A Trim the raw edges with pinking shears to prevent excessive fraying.

B Machine zigzag stitch along the raw edges of the seam allowance.

C Fold under the raw edges of the seam allowance and topstitch them close to the folded edge.

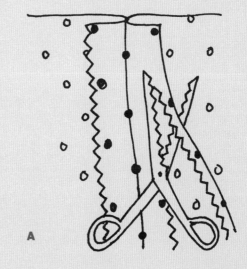

A

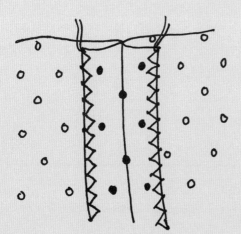

B

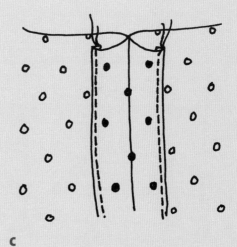

C

HEMS

At some point, you will probably want to change the length of a dress, skirt, or pair of trousers. To do so, you will need to fold over the fabric and stitch it in place, ensuring that the garment is the same length all the way around. Skirt and trouser hems cut on the straight grain of the fabric are worked in the same way. A circular skirt is a bit more difficult to hand hem because the fabric is wider at the base, and you have to ease in the excess fabric as you stitch.

Hand-stitched hems

1 Put on the trousers or skirt, stand on a stool, and ask a friend to measure the required length from the floor with a ruler and pin the hem up at intervals.

2 Take off the garment and mark the fold with pins. Mark a line about 6cm (2¼in) from the hemline with a water-soluble pen and cut away the excess fabric along this line. Mark the hemline in the same way so you can remove the pins.

3 Fold 6mm (¼in) of fabric to the wrong side along the edge of the hem and press as shown.

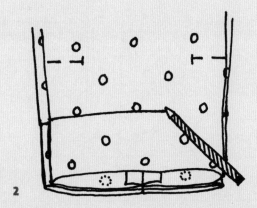

1

2

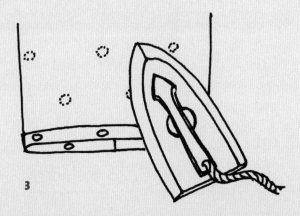

3

4 Fold the fabric to the wrong side along the marked hemline. Tack in position and remove the pins.

5 For an invisible hem, hand hem stitch the hem along the first fold as shown (see page 138). Remove the tacking and press.

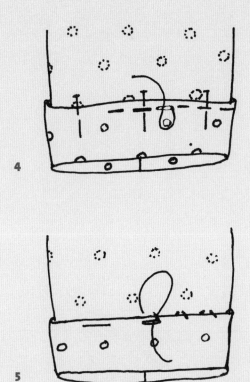

Machine-stitched hems

Machine stitching a hem is quicker, but the stitches will show on the right side of the fabric. Prepare a straight-cut hem for machine stitching, in exactly the same way as for a hand-stitched hem, pinning and tacking it in place. If you don't want to make a feature of the machine stitching, use a closely matched thread.

To prepare a curved hem for machine stitching, take in tiny pleats as you are tacking the hem in place, to ensure a neat result.

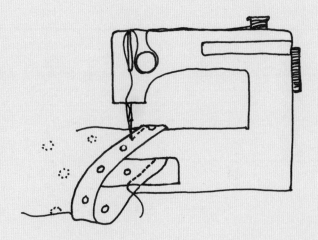

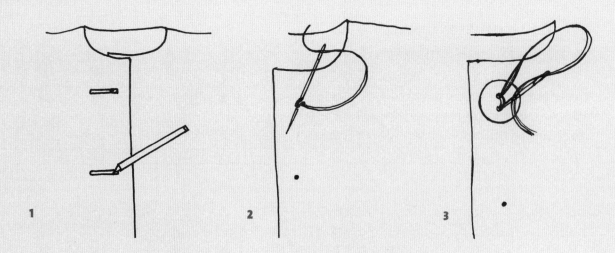

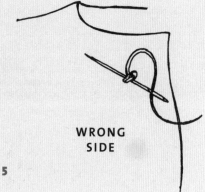

WRONG
SIDE

FASTENINGS

To fasten a waistband or jacket front, you will need to stitch on buttons, or hooks and eyes. Zippers are more complicated to insert and are best left to expert stitchers.

Sewing on buttons

Sewing on buttons might seem very basic, but it can be more tricky than it appears.

1 Close the garment and mark the position of the button through the buttonhole.

2 Using matching thread with a secure knot at the end, start to stitch the button in position. To prevent tearing fine fabric, add a small button to the wrong side of the fabric and stitch through it.

3 Sew in and out through the holes in the button at least six times.

4 Wind the thread several times around the threads behind the button.

5 Finish off by sewing at least twice through the back of the stitching on the wrong side of the fabric.

Sewing on hooks and eyes

It is important when sewing on hooks and eyes to make sure that you line them up exactly. To do this, you must pin the fastened hook and eye in position on the garment, mark the positions, take the hook and eye apart, and stitch them individually to each side of the opening.

1 Pin the eye in position on the wrong side of the fabric, so that the end of the eye overlaps the opening. Take the hook through the eye and pin it in position on the other side of the opening, making sure the hook is facing inwards.

2 Sew over the shaft of the eye as shown so it is secure, then sew over the ends. Lastly, sew over the shaft and the ends of the hook.

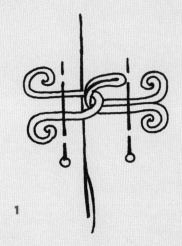

1

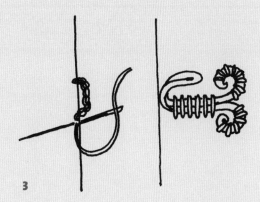

2

3 If you want to close the opening with a loop rather than an eye, follow the same steps to check the position, but make the loop on the edge of the opening as shown. (The instructions for making a loop are provided on the next page.)

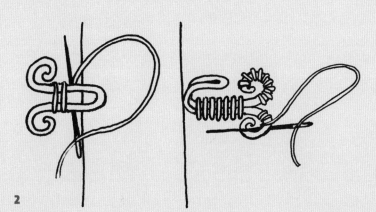

3

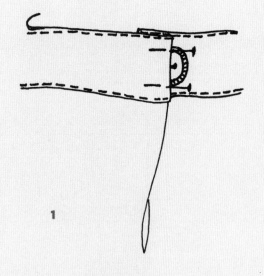

1

Making button loops

To make a button loop, first close the opening to the desired position, then mark the size of the button on the overlapping edge.

1 Mark the position of the loop at the top and bottom with pins as shown.

2 Secure the thread at the upper end of the loop position.

3 Make a series of chain stitches by pulling a loop of thread through each previously made loop as shown. (You can do this with your fingers or a fine crochet hook. If in doubt, ask a crocheter for help.)

4 When your chain is long enough to reach the bottom position, secure the thread with a few stitches, catching in the last chain loop.

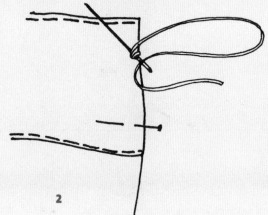

2

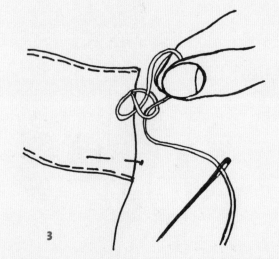

3

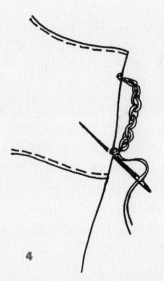

4

HAND AND EMBROIDERY STITCHES

Some of the projects in this book require hand sewing stitches and/or some hand embroidery stitches.

The basic hand stitches are tacking (basting), for temporarily holding two fabrics together, backstitch, for making seams, running stitch, which can be used both functionally and decoratively, and hemming stitch for invisibly stitched hems.

For the embroidery ideas in this book, I have used a few simple stitches: long and short stitch is used on the jacket lapels on page 45, feather stitch on the jacket on page 46, double feather stitch on the blouse on page 47, and lazy daisy stitch and French knots on the buttons on pages 48 and 49.

Tacking

For temporary tacking stitches, work long running stitches (see below) so they are easy to pull out.

Long and short stitch

Long and short stitch is a decorative running stitch (see below) made of alternating long and short stitches.

Running stitch

Running stitch is a series of short stitches that can be used for simple hems or seams, or for embroidery. Take several small stitches on the needle at once to speed up the stitching.

Backstitch

Backstitch can be used as a decorative stitch, but it is most commonly used for strong hand stitched seams. Start the stitch by taking one small stitch from right to left. Then bring the needle out a stitch length in front of the stitch just made. Work another stitch from right to left, and so on to make a continuous line of stitching.

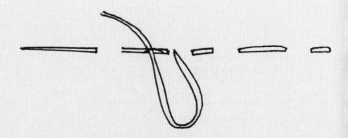

LONG AND SHORT STITCH

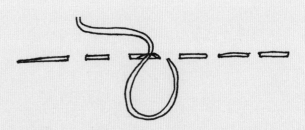

RUNNING STITCH

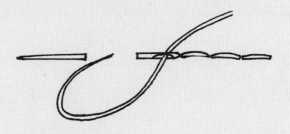

BACKSTITCH

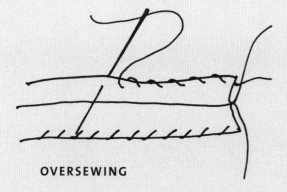

OVERSEWING

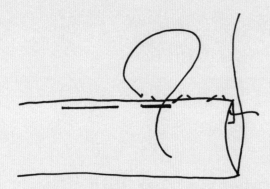

HEMMING STITCH

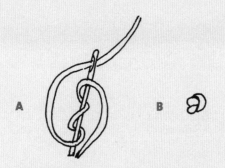

FRENCH KNOT

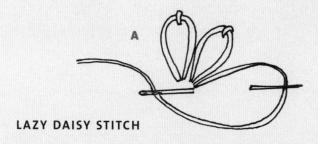
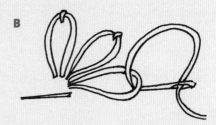

LAZY DAISY STITCH

Oversewing

Oversewing can be used to bind two folded edges of fabric together. It can also be used to hand finish the raw edges on seams as shown here.

Hemming stitch

Hemming stitch, also called slip stitch, is used to stitch hems in place. To work hemming stitch, take a small stitch through a fold of the hem, then a tiny stitch into the main fabric, and so on. Be careful to keep the stitching invisible on the right side of the garment.

French knot

French knots look like tiny beads. To work the stitch, bring the needle through from the back of the fabric, wind the thread around the needle a few times, then insert the needle back into the fabric close to where it first emerged (**A**), holding the twist of threads down with your finger to make the small knot (**B**).

Lazy daisy stitch

Lazy daisy stitch is a variation of chain stitch, which is a simple looped stitch. To start lazy daisy stitch, insert the needle through from the wrong side of the fabric, make a small loop, and reinsert the needle back through where it first emerged. Bring the needle up again inside the loop as shown (**A**). Then make a small securing stitch over the end of the loop (**B**). Repeat these stitches to create a circle like the petals of a daisy (hence the name).

Feather stitch

This decorative edging stitch is made in a similar way to lazy daisy stitch, by creating a series of loops. Bring the needle through from the wrong side of the fabric, then insert it a short distance from where it first emerged and bring it up inside the loop of thread as shown. Make a looped stitch like this to the right and to the left alternately to create the effect shown.

Double feather stitch

This is worked exactly as feather stitch, but two looped stitches are worked to the left, then two to the right to form a wider border.

Lane (or line) beading

Lane (or line) beading is a method for sewing on beads quickly. Bring the needle up from the wrong side of the fabric, string some beads onto the thread, then make a stitch from right to left the length of the beads (**A**). Stitch back over the thread holding the beads, making a short invisible stitch between each bead or between every few beads, as shown (**B**).

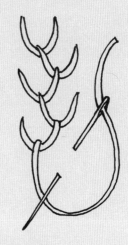

FEATHER STITCH

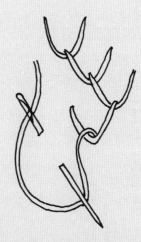

DOUBLE FEATHER STITCH

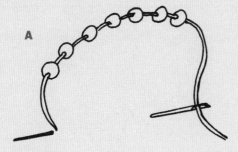

LANE BEADING

SUPPLIERS

UNITED KINGDOM
Fred Aldous
37 Lever Street
Northern Quarter
Manchester M1 1LW
08707 517300
General craft supplies

Barnyarns
Brickyard Rd
Boroughbridge
North Yorkshire YO51 9NS
0870 8708586
www.barnyarns.com
Water soluble fabrics, transfer adhesive and embroidery supplies

Coats Crafts UK
Lingfield Point
McMullen Road
Darlington
Co Durham DL1 1YQ
Consumer helpline: 01325 394237
www.coatscrafts.co.uk
Craft supplies, embroidery threads and haberdashery

Creative Beadcraft
Unit 2, Asheridge Business Centre
Asheridge Rd
Chesham
Bucks HP5 2PT
01494 715606
www.creativebeadcraft.co.uk
Beads and crystals (jewellery stones)

Dylon
www.dylon.co.uk
Contact by email on info@dylon.co.uk
Very helpful website offering information and advice on many aspects of dyeing fabrics

Hobbycraft Group Ltd
7 Enterprise Way
Aviation Park
Bournemouth International Airport
Christchurch
Dorset BH23 6HG
Tel 01202 596100
Fax 01202 506101
www.hobbycraft.co.uk
Freephone 0800 027 2387 for list of stockists of all kinds of craft materials

John Lewis plc
John Lewis Partnership
Partnership House
Carlisle Place
London SW1P 1BX
020 7828 1000
www.johnlewispartnership.co.uk
Fabrics, buttons and haberdashery

Omega Dyes
Tippet's Cottage
Kenwyn Church Road
Truro,
Cornwall TR1 3DR
01872 227323
email: lindsay@omegadyes.fsnet.co.uk
www.omegadyes.fsnet.co.uk
Several different dye types for differnt textiles

Stitch 'n' Craft
Swan's Yard
High St
Shaftesbury
Dorset SP7 8JQ
01747 852500
www.stitchncraft.co.uk
Beads and craft supplies

VV Rouleaux
6 Marlebone High St
London W1M 3PB
020 7730 5179
www.vvrouleaux.com
Braids and ribbons

AUSTRALIA

Australian Country Spinners
314 Albert Street
Brunswick
Victoria 3056
Tel: (03) 9380 3888
E-mail: sales@auspinners.com.au
Fabrics and haberdashery

U.S.A.

Coats & Clark
4135 South Stream Boulevard
Charlotte
North Carolina 28217
001 704 329 5016
Embroidery and sewing threads and haberdashery

Habu Textiles
135 W. 29th Street
Suite 804
New York, NY10001
001 212 239 3546
www.habutextiles.com

USEFUL ORGANIZATIONS

The Crafts Council
44a Pentonville Road
London N1 9BY
020 7806 2503
www.craftscouncil.org.uk

The Embroiderer's Guild
Apt 41
Hampton Court Palace
Surrey KT8 9AU
020 8943 1299
administrator@embroiderersguild.com
www.embroiderersguild.com
*Runs courses, classes, events, workshops and also
publishes Embroidery (see below)*

USEFUL MAGAZINES

Embroidery
PO Box 42B
East Molesey,
Surrey KT8 9BB
01260 295735
email: jhall@embroiderersguild.com

Fiberarts
International orders
+1 760 291 1531
www.fiberarts.com

Selvedge
PO Box 40038
London N6 5UW
editor@selvedge.org
www.selvedge.org
020 8341 0248

INDEX

AUTHOR'S ACKNOWLEDGMENTS

This book really has been a team effort! I would like to thank Anna Sanderson for never giving up on the idea and Susan Berry for finding the team and making the whole project work. I also want to thank John Heseltine for his beautiful photography and his humour, Janet Haigh for her inspirational drawings, and for the use of her house and her fantastic food, and Anne Wilson for collecting all our ideas together in such an elegant design.

As always thanks to my friends and family for being constantly supportive, inspirational and wonderful.

PUBLISHER'S ACKNOWLEDGMENTS

The publishers would also like to thank Sally Harding for her editorial work and Marie Lorimer for proof-reading and the index.